IMAGES
of America

JEWS OF WEEQUAHIC

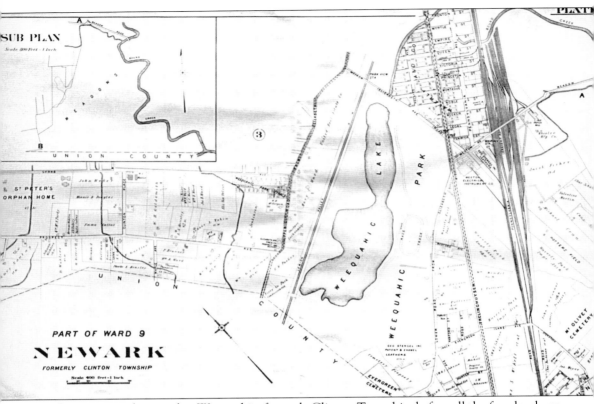

This map reveals an earlier Weequahic, formerly Clinton Township, before all the farmland was sold to housing developers in the early 1920s. (Courtesy Sandra Greenberg.)

On the cover: High-stepping majorettes on the steps of Weequahic High School in 1944 are promoting the sale of war bonds. Weequahic students joined the armed forces. A plaque outside the auditorium at Weequahic High School memorializes 57 Weequahic students who lost their lives in World War II. (Courtesy Weequahic High School Alumni Association.)

IMAGES
of America

JEWS OF WEEQUAHIC

Linda B. Forgosh

ARCADIA
PUBLISHING

Published by Arcadia Publishing
Charleston SC, Chicago IL, Portsmouth NH, San Francisco CA

Printed in the United States of America

Library of Congress Catalog Card Number: 2007935344

For all general information contact Arcadia Publishing at:
Telephone 843-853-2070
Fax 843-853-0044
E-mail sales@arcadiapublishing.com
For customer service and orders:
Toll-Free 1-888-313-2665

Visit us on the Internet at www.arcadiapublishing.com

*It is to Betsy Rosenberg Krichman, class of 1958,
and those who lived the history of this one-time legendary Jewish
neighborhood in the city of Newark that this book is dedicated.*

CONTENTS

ACKNOWLEDGMENTS

A decision to research a subject as grand and important as the history of Jewish life in Newark's Weequahic section was made with the consent and enthusiastic support of the Weequahic High School Alumni Association and the board of trustees of the Jewish Historical Society of MetroWest, which is a beneficiary agency of the United Jewish Communities of MetroWest, the cooperation of the editor and staff of the *New Jersey Jewish News*, and the overwhelming support of hundreds of one-time Weequahic residents who shared their memories, photographs, and precious memorabilia with the author of this book.

Added to this mix are Weequahic's elementary and high school reunion committee members who, with great dedication and persistence, make it possible for fellow classmates and one-time neighbors around the country to keep in touch; the Weequahic High School Alumni Association's publication of an alumni edition of the school newspaper, the *Calumet*, which posted requests for information; and the incredible effort of Jac Toporek, class of 1963, who monitors, polishes, and distributes a weekly e-mail newsletter with 2,000 subscribers who recall growing up in Weequahic like it was yesterday.

Thanks go to Jewish Historical Society of MetroWest staff Jennifer McGillan, Jeffrey Bennett, and Susan G. Rivkind for assistance in preparation for this book. Erin Rocha, Arcadia editor, kept a watchful eye on all the publishing details. Thanks also to Arcadia proofreader Sara Desharnais.

The largest thank-you is reserved for the founders of the Jewish Historical Society of MetroWest, Ruth and Jerome Fien and Saul Schwartz, whose commitment to preserving Newark's Jewish history made this book possible. Last is the author's apology for misspelled names and for omitting any part of Weequahic's history that was not shared with her.

INTRODUCTION

Described as "Newark's frontier" by Pulitzer Prize–winning novelist Philip Roth, the Weequahic section in the city of Newark was one of the last sections of the city to be developed. Pronounced "Wee-qua-chick," meaning "head of the cove," this is the only neighborhood in Newark with a Native American name.

Between 1910 and 1930, farmland known as Lyons Farms was converted to wide "tree-lined streets with frame wooden houses and red brick stoops" with a sampling of large historic revival houses enabling a second generation of Jews living in the city's impoverished Third Ward tenements, or the Prince Street neighborhood, to move to open spaces.

Bound by Hawthorne, Elizabeth, and Lyons Avenues and Fabyan Place, approximately 58 streets define the Weequahic neighborhood. Not located in the Weequahic section but bearing the same name is historic Weequahic Park. For Weequahic's Jews, the park was a paradise for sports lovers. There were free horse races, tennis courts, and a public golf course that was the oldest public golf course in the United States.

Weequahic's Jewish families utilized the park's facilities all year round. Visitors could boat, fish, or ice-skate on an 80-acre lake, families picnicked, youngsters in carriages, or perambulators, were accompanied by their baby nurses, and band concerts were a large draw. Best of all, Weequahic Park was within walking distance of the neighborhood.

On hot summer nights, parents would pile their children in the car and park "at the lake at Weequahic Park, lining up with the rest of the cars, trying to catch a breeze off the lake. When that didn't work, [they] traveled to a place called Watermelon King to have a cold slice of watermelon."

As an aside, during World War II, the army occupied a large part of the park for a military hospital and barracks for service personnel for the air force located at Newark Airport.

Weequahic Historic District, so designated in 2003, includes the entire park and 28 blocks bound roughly by Elizabeth, Renner, Maple, and Lyons Avenues. The streets are easily recognizable as they have distinctive street signs that state "Weequahic."

Newark historians Dr. Clement Price, Warren Grover, and Elizabeth Del Tufo conduct regular tours of the neighborhood. Newark Museum and the Newark Preservation and Landmarks Committee also sponsor tours of the neighborhood.

Jeffrey Bennett, creator of the Web site Newarkology, offers an ideal walking tour of Weequahic landmarks that starts at Weequahic Park's Divident Hill Pavilion near the intersection of Lyons and Elizabeth Avenues, guides the walker toward Mapes Avenue to view the statue of New Jersey governor Franklin Murphy, goes past Zion Towers and the site of the former Tavern Restaurant at the intersection of Pomona and Elizabeth Avenues, and continues to 725 Elizabeth Avenue,

the site of the private home built as an Ideal home and showplace for New Jersey's largest department store, L. Bamberger and Company, in 1923.

One of the finest examples of art deco architecture is the apartment building located at 19 Lyons Avenue, which was home to Newark's only Jewish mayor, Meyer C. Ellenstein, and other upper-middle-class residents.

A brief turn onto Bergen Street leads to Chancellor Avenue, Weequahic High School, and the newly refurbished Untermann Field, originally dedicated in 1939.

Other sites on Chancellor Avenue include the home of Lili Kaufman, daughter of Yiddish storyteller Sholom Aleichem; the building that housed the Hebrew Sheltering Home; the faded exteriors of several neighborhood synagogues; and the building that served as Newark's YMHA/YWHA, or "Y," from 1959 to 1969.

Turning on Aldine Street, walkers come to another main thoroughfare, Lyons Avenue. This is the location of Newark Beth Israel Medical Center. The late Dr. Murray Belsky, who grew up in Weequahic and practiced at the hospital, was fond of saying that the Beth, or Newark Beth Israel Medical Center, and Weequahic High School are two of the proudest institutions in Newark's South Ward.

On the subject of synagogues, 20th-century Newark was home to as many as 43 synagogues. According to a 1962 edition of the *Jewish News*, the Weequahic section was home to 17 of these synagogues.

Synagogues had official Hebrew names such as Ahavath Israel or B'nai Jacob Tzemach Tzedeck, but for the most part residents referred to the synagogues by their street locations. Hence, there was the Wainwright Street synagogue or Avon Avenue shul. The last synagogue to close was B'nai Moshe, which was converted to a senior center until its close in 1984.

Orthodox Jews mostly recall Rabbi Zev Segal's Young Israel and Rabbi Gedaliah Convissor, who held the "ruler" that kept his Schley Street Hebrew school students in line.

In addition to the synagogues, Weequahic's Jews supported a Talmud Torah, or Hebrew school, which was located on Osborne Terrace. Howard Botnick recalls attending Hebrew school classes when they were conducted over Nusbaums Drug Store on the corner of Lehigh Avenue and Bergen Street across from the fire station.

Bob Goldberg recalls that young boys would be approached on the street and asked while walking if they were a bar mitzvah for the purpose of joining a minyan, or religious service, in a nearby synagogue that was starting at that moment.

Nat Bodian, author of numerous Newark history vignettes found on the Old Newark Web site, reminds that in the 1930s Weequahic had as many as 140 Jewish fraternal and family associations, Newark branches of 16 national organizations, 8 athletic clubs, and 3 political clubs. There was never any want for something to do.

Remembered fondly is the South Ward Boys Club supervised by Dave Warner, who held meetings in the basement of his home. When the group exceeded 50 members, it met at Tunis Mansion on Bergen Street in the building that was the Hawthorne Movie Theater. The group's annual trip to the Capitol building in Washington, D.C., was noteworthy.

There also were active Boy Scout and Girl Scout troops that met at the Y or local synagogues. Once the scouting bug bit, one was hooked for life. Alumni of Newark's Robert Treat Scouts, which included Weequahic youngsters, assembled for a 50th anniversary reunion at Camp Mohican located in Blairstown in the fall of 2007.

Another club, the Renner Association, whose records are kept by one of its long-tenured presidents, David Horwitz, was established in the late 1940s. This group of young men who hung out at the corner of Goodwin and Renner Avenues near Weequahic Park rented a vacant store at 113 Goodwin Avenue, installed a television, and had a place to call their own. More than 60 years later, the members of the group still find time to keep in touch.

There were other clubs that attracted neighborhood youngsters such as the Le Cheries and the Sorrells that met at the Y on Chancellor Avenue and Parkview Terrace. There was the Marauders, a recreational basketball league. There were social and athletic groups such as the Sil-o-ets,

Starlets, Braves, Esquires, Redskins, Satans, Senecas, Indians, Filantes, Oriole AC's, the Alpha, Alpha, Delta and Sigma Alpha Rho fraternities, and a "Sunday morning" group that meets every two years, albeit sometimes on Thursday evenings, of men who earned sports letters.

Sports were a unifying force in the neighborhood. Young boys hung out at local parks, school yards, and recreation centers perfecting their baseball and basketball skills waiting for older boys to include them in a game. Young girls played a game referred to as Russia, which involved nothing more than owning a pink Spalding ball and knowing how to bounce it against the wall and catch it.

Weequahic had its own stores, eateries, "its own pride, and its own way of life." Bergen Street, the city's longest street, was a bustling, vibrant commercial center.

Small family businesses of bakers, butchers, tailors, opticians, luncheonettes, jewelers, and clothiers set up shop. There was an active Bergen Street Merchants Association, Hawthorne Avenue Merchant's Association, and the 9/16 Civic Association.

One-time eateries such as Henry's Sweet Shop; Kiel, Wigler, and Silver bakeries; hot dog vendors Syd's, Sabins, and Millmans; luncheonettes Margie's, Harjay's, and Belfer's; Amato's Pizzeria; Ming's Chinese; Cohen's Knishes, Tabatchnick's, and Eppes Essen delicatessens; the ultimate bagel maker, Watson's; the upscale Tavern Restaurant; and the renown Weequahic Diner, home of glorious cheesecake and Claremont salad are topics of endless conversations about the mouth-watering good old days.

Added to this mix of eateries is David Moskowitz's recollection that "on Chancellor from Leslie to Hobson was Al Cohen's Grocery; then the shoemaker, the barber shop, the Acme that became Bernheims' funeral parlor, the Hot Dog Haven, and The Bunny Hop," famous for its huge steak sandwiches called Jerry Bombs.

The flavor of the neighborhood was captured in Esther Gordon Blaustein's book, *When Momma Was the Landlord*. Blaustein recalls the clothespins that constantly fell off the laundry lines of renters who all shared a common backyard. Claiming the clothespins was not an easy task for those on the third floor as 12 clothes lines provided an endless number of pins for which to contest ownership.

Lasting friendships started in grammar school. There were Chancellor Avenue, Maple Avenue, Hawthorne Avenue, Peshine Avenue, Avon Avenue, Bragaw Avenue, and Bergen Street elementary schools. After eighth-grade graduation, students attended the Weequahic Annex for ninth grade and moved to the high school for grades 10 through 12. To this day, nothing draws a crowd quite like a Weequahic High School reunion or homecoming football game.

Weequahic High School, which opened in 1933, had such a large student population that it was necessary to hold January and June graduations, a practice that lasted until 1964. It was also possible to graduate from Weequahic High School in three and one-half years. David Shapiro, author of 10 volumes of poetry, including the poem "Weequahic Park in the Dark," graduated early to attend Columbia University.

A number of Weequahic graduates have gone on to fame and fortune. The most frequently mentioned name is that of author Philip Roth. Roth has published numerous works that have as their central characters individuals the writer knew as a boy growing up in Weequahic. This includes the character Swede Levov in *American Pastoral*. Roth's Swede was modeled after Weequahic's, Newark's, and New Jersey's hall of fame athlete, Seymour "Swede" Masin, class of 1938.

As America's most prolific writer of the last quarter of the 20th century, Philip Roth was honored in 2005 by the Newark Preservation and Landmarks Committee with the placement of a historic site plaque on Roth's Weequahic home located at 81 Summit Avenue.

In an effort to see "what happened" to a sampling of its graduates, anthropologist Sherry B. Ortner, a graduate of Weequahic High's class of 1958, spent 10 years interviewing fellow classmates for her book *New Jersey Dreaming: Capital, Culture, and the Class of '58*. Ortner gives the reader "an account of how her class got from its modest, largely working and middle-class origins in the late 1950s to a situation where 60 percent of the members of the class would be described as part of America's 'white overclass.'"

Ortner confirms that Weequahic graduates are everywhere when she notes that "I rarely give a talk at an academic institution without someone standing up and saying that he or she or his or her parent went to Weequahic."

Every student seemed to have his or her favorite teacher. The excellence and academic credentials of Weequahic's teachers was beyond reproach. One teacher, Simon Chasen, taught foreign languages, including Russian, Hebrew, an Indonesian dialect, classical Greek, and Swahili. Sam Hilt, class of 1965, and Stuart Friedman, class of 1959, recall that Chasen "taught you their [the languages'] histories, evolution, and migration patterns across cultures and languages" and that Chasen "used to ride the buses in New York just to listen to the conversations of people from all over the world."

On the political, spiritual, and cultural front, Weequahic graduate Rabbi Michael Lerner, editor of *Tikkun* magazine, recalls that "my mother and father were national leaders of the Zionist movement in the U.S. My mother used to talk proudly of how, at five years old, I was standing outside the local bank on Bergen Street in the mostly-Jewish Weequahic section of Newark, NJ," collecting money to plant trees in Israel. This is the right time to mention Bet Yeled, a Labor Zionist school located on Lyons Avenue.

Statistics shed a different light on Weequahic's Jewish history. In 1948, Weequahic was home to an estimated 35,000 Jewish residents. Surveys in 1936 and 1937 reveal that the majority of the 8,446 students enrolled in Weequahic's grammar schools and the 2,596 students that were attending Weequahic High School were Jewish.

These numbers would decrease rapidly as the lure of more land and larger homes in suburban Essex County enticed a new generation of Newark's upwardly mobile Jewish families. By 1977, Lawrence Schwartz, author of the article "Roth, Race, and Newark," estimated only 500 Jews remained. However, absence of Jews in Weequahic today cannot diminish their collective legacy to the city and to their moment in history.

Nevertheless, lasting friendships, some reaching back 60 or more years, make attendance at school reunions a must. A member of the class of 1945 travels from Quito, Equador, to touch base with his high school chums. Reunions are held in California, Florida, Arizona, Connecticut, and New Jersey, or any place in the United States where graduates have settled. Sometimes it only takes two to constitute a reunion.

Loyalty to the neighborhood prompted the formation of a Weequahic High School Alumni Association in 1997. With some 4,000 subscribers on its mailing list, the alumni association has dedicated itself to raising significant amounts of money to fund scholarships for current Weequahic High School students. The association's executive director, Phil Yourish, maintains a full run of the school's yearbook, the *Legend*. Hence, there is no question as to who qualifies to be labeled a Weequahic graduate.

The Weequahic High School Alumni Association publishes a quarterly newsletter, the *Calumet*. This is the original name of the high school's newspaper. There is also *La Calumette*, which gives news about graduates in the Los Angeles area, and the *Calumet, Again*, published three times a year by class of 1945 reunion chairman David Horwitz. Added to this mix is the weekly e-mail newsletter maintained by Jac Toporek, class of 1963, which has several thousand subscribers, each taking turns recalling what it was like to grow up in Weequahic, or Newark's legendary neighborhood.

Seasoned politicians claim that the most select club in America is that of 100 senators who serve in the United States Senate. To the more than 700 Weequahic High School graduates who crowded the ballroom of Newark's historic Robert Treat Hotel in 2006 to honor one of their own, basketball legend Alvin Attles, or the capacity crowd that filled the 500 seats at a local movie theater for a preview of the movie *American Gangster*, based on the career of class of 1956 Weequahic graduate Richie Roberts, the most select club in America admits only those individuals who are privileged to say that they hail from Weequahic. In short, the history of Jewish life in Weequahic is worth the read.

One

WEEQUAHIC PARK
A PLAYGROUND FOR ALL SEASONS

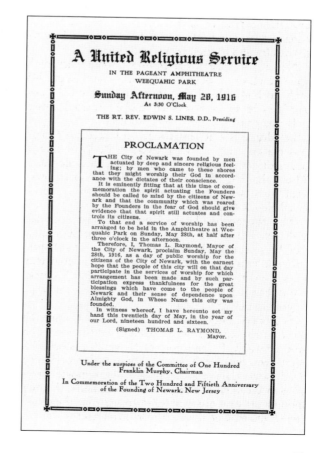

Weequahic Park was the site for a religious service commemorating Newark's 250th anniversary in 1916. Among the speakers for the event was Rabbi Solomon Foster of Newark's oldest synagogue, Temple B'nai Jeshurun. (Courtesy Nancy Leon Herman.)

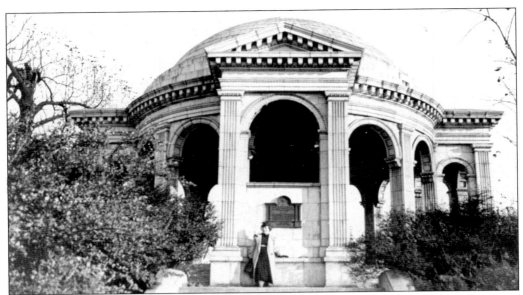

Divident Hill Pavilion (the word *divident* being an archaic term for "divided") was the site of the boundary conference between the city fathers of Elizabethtown and Newark in 1668. The actual pavilion was built for Newark's 250th anniversary. (Courtesy Jewish Historical Society of MetroWest Archives.)

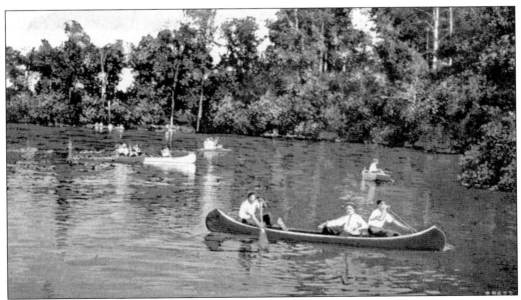

The centerpiece of Weequahic Park is its 80-acre lake. Jewish residents recall how the lake was stocked with fish. In fact, fishing derbies are still popular today. Sylvia Kaufman Horowitz recalls that there had to be seven inches of ice on the lake before it was safe for skating. (Courtesy Sheldon Bross and Bernice Werner.)

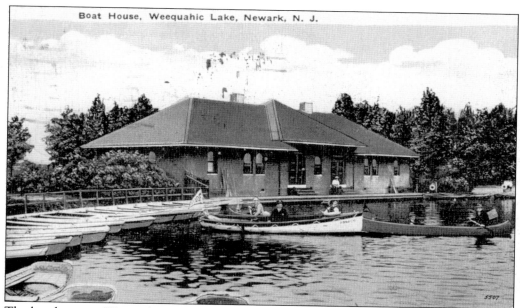

The boathouse at Weequahic Park rented rowboats and canoes. (Courtesy Sheldon Bross and Bernice Werner.)

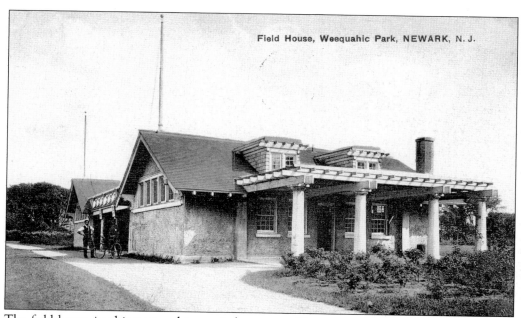

The field house in this postcard image is long gone. However, a newly organized Weequahic Park Association has an all-purpose building on the park grounds. (Courtesy Sheldon Bross and Bernice Werner.)

13

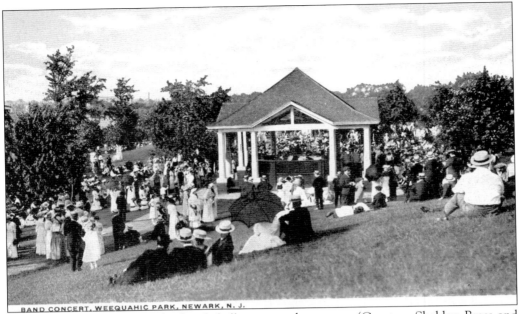

BAND CONCERT, WEEQUAHIC PARK, NEWARK, N. J.

Summer concerts at the park's band shell were regular events. (Courtesy Sheldon Bross and Bernice Werner.)

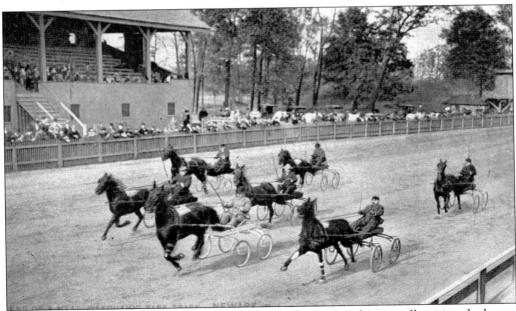

The trotters at the park's racetrack were a popular attraction. Residents recall visiting the horses that were kept in stables at the back of the track. (Courtesy Sheldon Bross.)

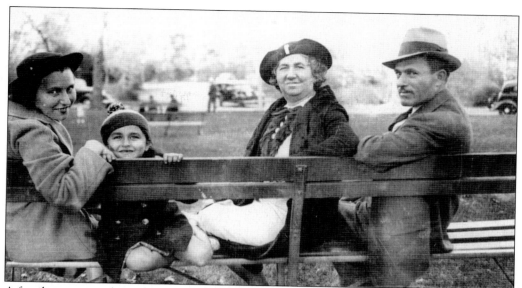

A family outing in the mid-1930s features the Blumenfeld family: from left to right are Florence, Judy, Rebecca, and Harry. The family walked from Goldsmith Avenue to Weequahic Park. Judy recalls feeding the ducks. (Courtesy Judy Blumenfeld Schatzberg.)

Former Weequahic resident Joseph Posner captures his memories of the park in his poem "Weequahic Park." (Courtesy Daisy Pujols.)

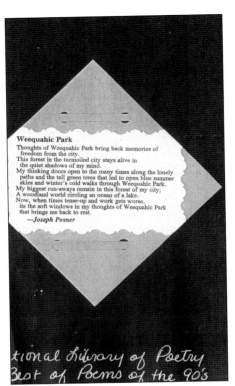

*tional Library of Poetry
Best of Poems of the 90's*

"Weequahic Park" is in the Best Poems of the
90s series, in the International Library of Poetry.
(Courtesy Joseph Posner.)

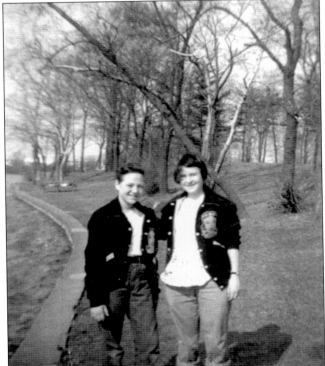

This 1957 snapshot taken in
Weequahic Park features Marian
Kaufman Braverman (left) and
friend Judy Shulman. (Courtesy
Marian Kaufman Braverman.)

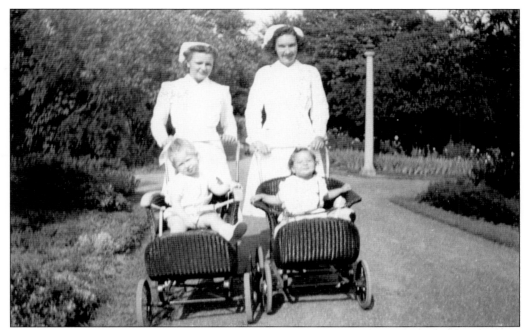

Secure in their carriages, or perambulators, being pushed by their uniformed baby nurses are Linda Tepper (left) and Linda Zimmerman Willner. (Courtesy Linda Zimmerman Willner.)

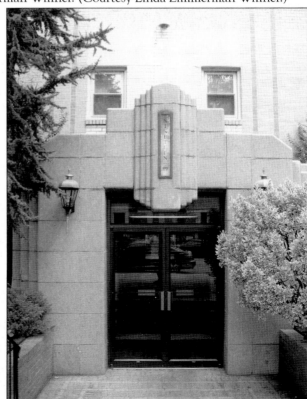

Flanking Weequahic Park is a series of art deco apartment buildings, including 25 Van Velsor Place, 1 Lehigh Avenue, and 19 Lyons Avenue, that were home to upper-middle-class Jewish families. This is the entrance to 19 Lyons Avenue. (Courtesy Jeffrey Bennett.)

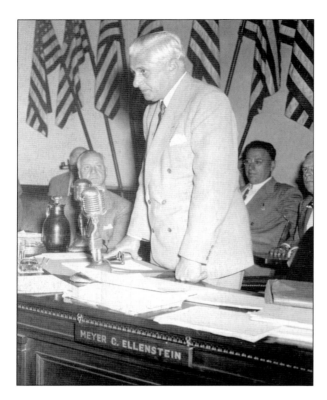

Newark has had only one Jewish mayor, Meyer C. Ellenstein, who served from 1933 to 1941. Ellenstein lived in the Weequahic section in an apartment building located on Lyons Avenue. (Courtesy Jewish Historical Society of MetroWest Archives.)

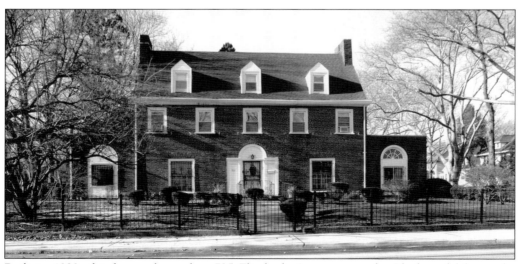

Built in 1923, this house, located at 725 Elizabeth Avenue, was the Ideal model home for showcasing furniture and decorative accessories sold at L. Bamberger and Company, Newark and New Jersey's largest department store. (Courtesy Harold Kravis.)

Another park, Olympic Park, on the border of Irvington and Weequahic, was a popular destination for Weequahic's Jews. Artist Helen Frank is holding a picture that she sketched of the horses on the merry-go-round. Olympic Park's merry-go-round is now at Disneyworld. (Courtesy Jewish Historical Society of MetroWest Archives.)

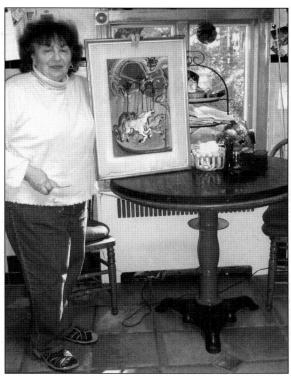

49 A MODERN MERMAID PAINTING BY ARTHUR
COPYRIGHT, 1906, BY BROWN & BIGELOW, ST. PAUL AND TORONTO

═══ A ═══

Weequahic Park Lake

GIRL

Weequahic Park owes its design to renowned landscape architect Frederick Law Olmsted and his sons. This charming postcard is a complement to the young woman seated by the lakeside in the photograph on the following page. (Courtesy Sheldon Bross.)

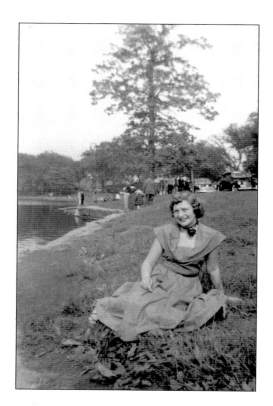

In the days before air-conditioning, Weequahic residents would spend time at the lake at Weequahic Park to catch the cool breezes. This is Gayle Brody in the 1950s. (Courtesy Gayle B. Jacobs.)

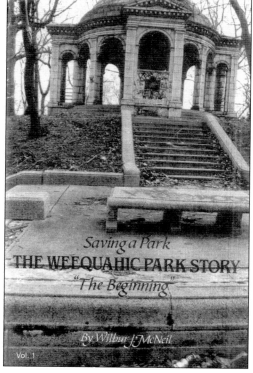

After years of neglect, Weequahic Park is being restored to its early splendor. A newly established Weequahic Park Association is headed by Wilbur J. McNeil. (Courtesy Wilbur J. McNeil.)

Two

School Days, School Days

Weequahic Elementary Schools

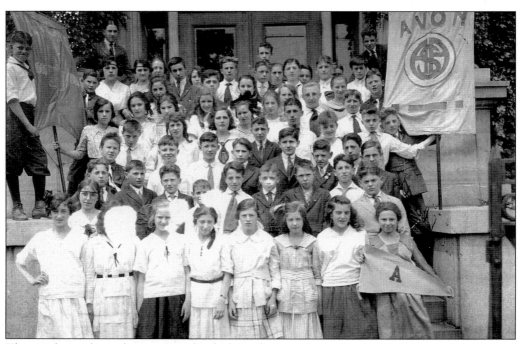

This is the earliest elementary school class photograph in the Jewish Historical Society of MetroWest Archives. It is the Avon Avenue School class of 1919. Donor Leila Jacobsen's father, Philip Deutsch, was a member of the class. (Courtesy Leila Jacobsen.)

Helen Yeager Gottlieb attended Chancellor Avenue elementary school and graduated with the class of 1935. There were daytime classes for adults in English and citizenship held at the Chancellor Avenue public school during the 1930s. (Courtesy Helen Yeager Gottlieb.)

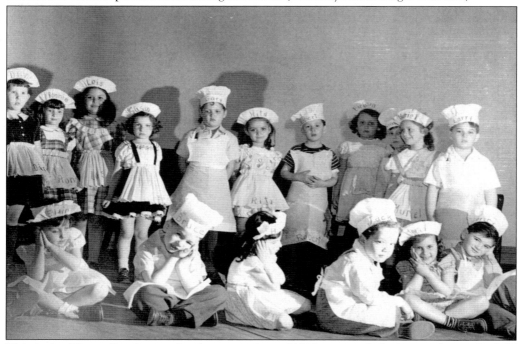

This is the Chancellor Avenue kindergarten class of 1948 wearing baker's caps that each child made. (Courtesy Diane Martin.)

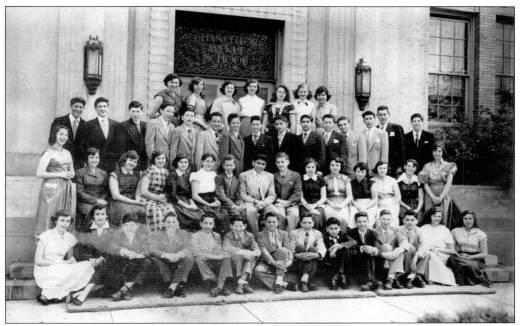

This is the Chancellor Avenue School class of 1951. Michael Warner, class of 1953, recalls the visiting circus that was located on adjacent Untermann Field. Students could hear the roar of the lions inside the classrooms. (Courtesy Monroe Krichman.)

At their 35th Chancellor Avenue School reunion, these graduates are members of Weequahic High School's class of 1958. (Courtesy Linda Zimmerman Willner.)

Chancellor Avenue School graduate Sara Friedman Fiskin, class of 1956, recalls playing "knock hockey" in the playground and school air raid drills. (Courtesy Jewish Historical Society of MetroWest Archives.)

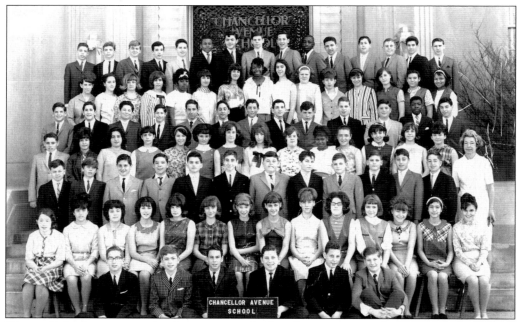

Weequahic's elementary schools were named after the streets on which they were located. Among the most popular were Hawthorne, Chancellor, Avon, Maple, Bragaw, Bergen, and Peshine. This is Chancellor Avenue's class of 1965. (Courtesy Jewish Historical Society of MetroWest Archives.)

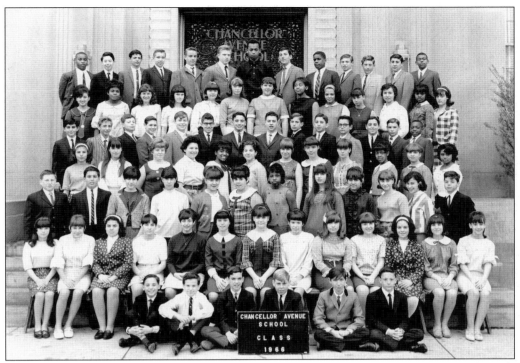

Members of this Chancellor Avenue class report that they have held on to their eighth-grade autograph books as another way to document their childhood memories. (Courtesy Jewish Historical Society of MetroWest Archives.)

Maple Avenue School is located across the street from Newark Beth Israel Medical Center on Lyons Avenue. Students recall cutting through the main lobby of the hospital on their way home from school. (Courtesy Dr. Julian Orleans.)

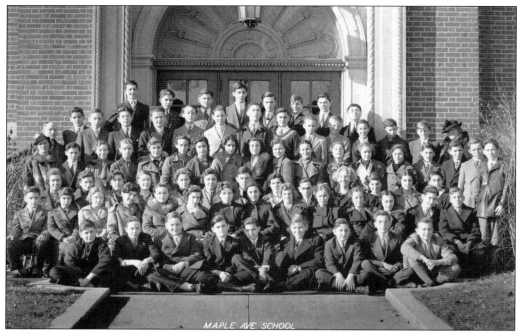

Maple Avenue School students recall sitting on the steps of Newark Beth Israel Hospital during lunch hours and having a bite to eat at the hospital's coffee shop when it opened in the mid-1930s. (Courtesy Mitzi Reisen.)

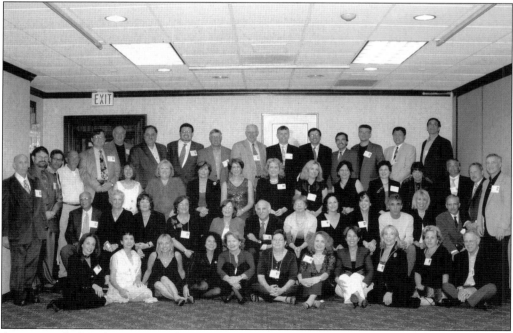

A reunion for Maple Avenue School's class of 1960 drew a large crowd. Jane Straus Wildstein recalls that Maple Avenue School drew from residents from Huntington Terrace, Renner, and Schuyler Avenues. (Courtesy Jane Straus Wildstein.)

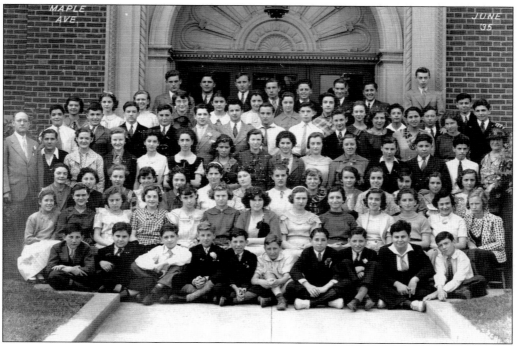

These Maple Avenue School graduates became the Weequahic High School graduating class of 1939. (Courtesy Seymour Some.)

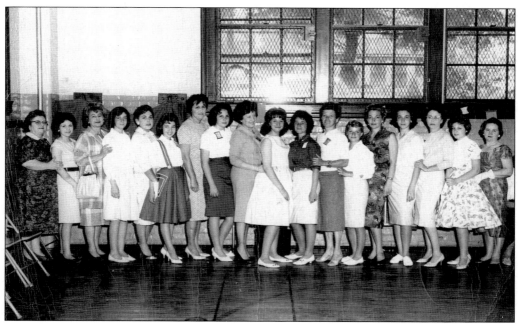

A mother-and-daughter tea in 1960 for Maple Avenue School eighth-grade students features Norma Mark, Marcia and Ida Kay, Mona Gold, Harlie Colin, Jane and Adele Straus, Rosalie Hodes, Lorraine and Frances Glass, Judy Sobo, and Ruth Klein. (Courtesy Jane S. Wildstein.)

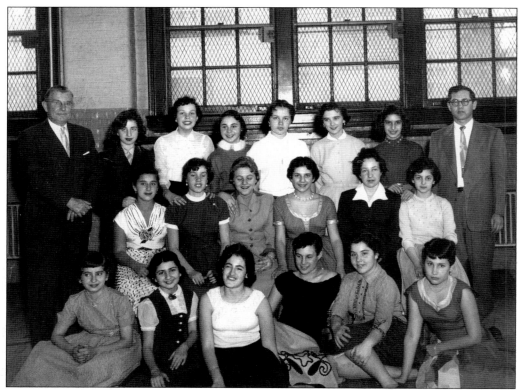

Girls in the gym at Maple Avenue School are attending the 8A Valentine Day buffet in 1954. From left to right are (first row) Carol Schildkret, Claire Mayers, Janet Ehrenkrantz, Joynce Finkel, Anita Brown, and Ann Winkler; (second row) Elaine Schapira, Blanche Cooperman, Barbara Ades, Phyllis Mandel, Marilyn Fisher, and Carol Grossman; (third row) Mr. Townsend, Enid Kesselman, Ellen Brodsky, Joan Davis, Barbara Lee, Francine Garfinkel, Betsy Rosenberg, and Mr. Charnes. (Courtesy Claire Mayers Nierenberg.)

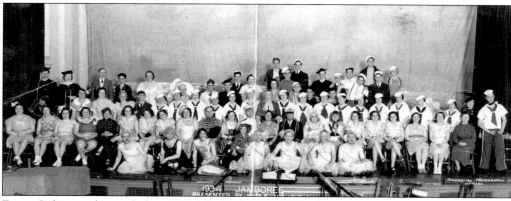

Erma Coleman directed this 1934 Maple Avenue School PTA jamboree. Judging from the number of sailor hats and uniforms, there was a nautical theme. (Courtesy Jewish Historical Society of MetroWest Archives.)

Grammar school homeroom classes were encouraged to save for the future. This passbook savings account was started by a kindergartener in 1937. (Courtesy Judy Blumenfeld Schatzberg.)

Seymour Spiegel recalls attending Hawthorne Avenue School from 1937 to 1943. According to Jac Toporek's Weequahic e-mail newsletter, at this time, there were wooden floors in the old wing, a playground surrounded by an enormous three-story chain-link fence, and a fine gravel surface for playing baseball and basketball. (Courtesy Jewish Historical Society of MetroWest Archives.)

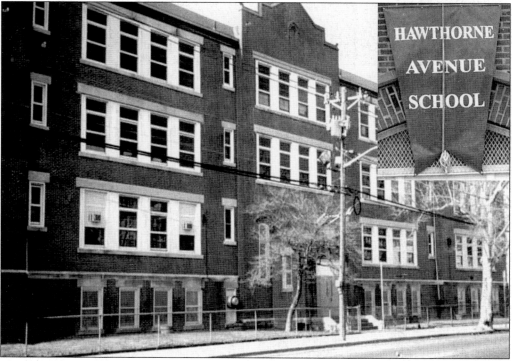

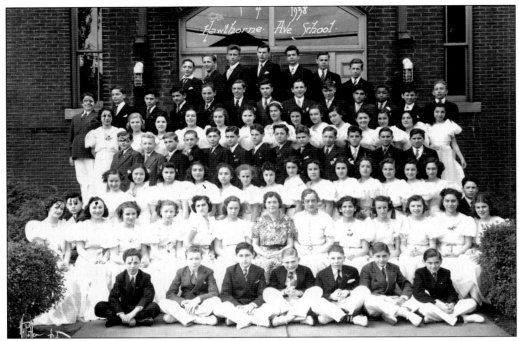

Students in Weequahic's grammar schools attended ninth grade at the Weequahic Annex, which was located on Hawthorne Avenue, including this Hawthorne Avenue class of 1938. (Courtesy Harold and Carol Kroll Blinder.)

Happily, Hawthorne Avenue School's class of 1938 graduates recorded their names on the back of their class photograph. (Courtesy Harold and Carol Kroll Blinder.)

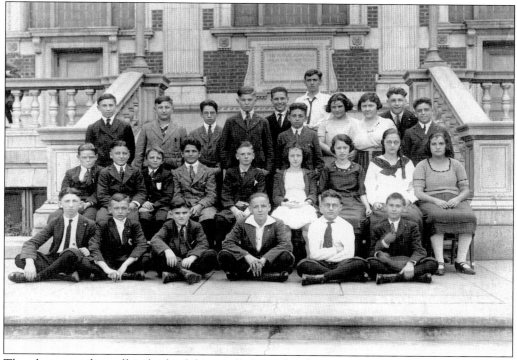

The plaque on the wall in back of this small class of students at Cleveland Junior High School on Bergen Street in 1926 reads, "The Public Schools Are the Place to Be." (Courtesy Jewish Historical Society of MetroWest Archives.)

This is Bergen Street School as seen in 1949. (Courtesy Elliott Sudler.)

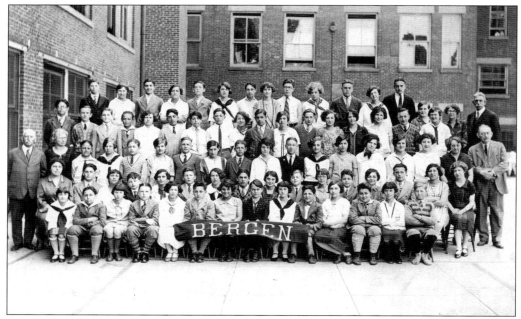

Joel Schwarz graduated with Bergen Street School's class of 1926. Schwarz was the grandson of Rabbi Isaac Schwarz, the first rabbi of Congregation Oheb Shalom, in 1860. Joel was the first president of the Weequahic YMHA/YWHA (1954–1957). (Courtesy Jewish Historical Society of MetroWest Archives.)

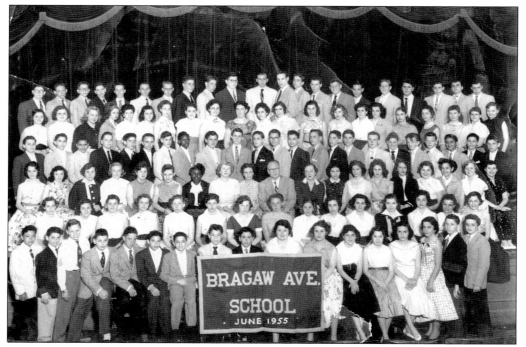

Bragaw Avenue graduate Priscilla Glinn recalls the school's Dreamboats and Knights social groups. (Courtesy Marian and Mel Braverman.)

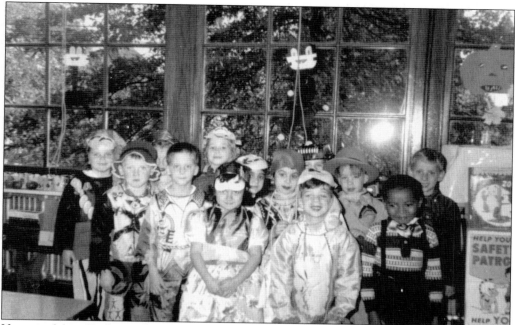

Here is Mrs. Kaplan's first-grade class at Bragaw Avenue School in 1958. (Courtesy Carol Bernstein.)

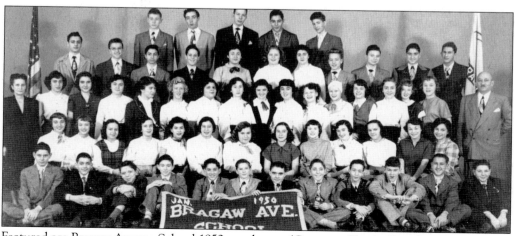

Featured are Bragaw Avenue School 1950s graduates. (Courtesy Charles Bernhaut.)

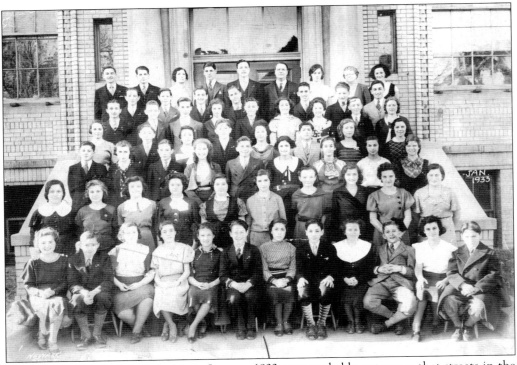

Peshine Avenue School graduates in January 1933 were probably not aware that streets in the Weequahic neighborhood were named for historical figures such as John Peshine, a prominent Newark leather manufacturer. (Courtesy Paula Convissor Gash.)

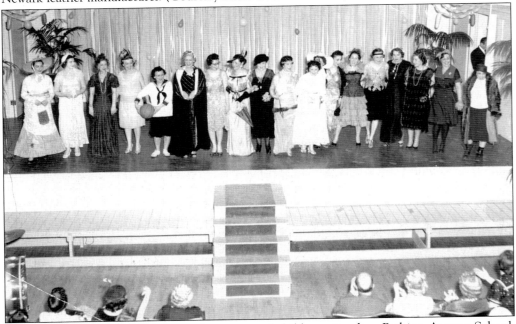

A musical review in 1953 features the parents of children attending Peshine Avenue School. (Courtesy Jewish Historical Society of MetroWest Archives.)

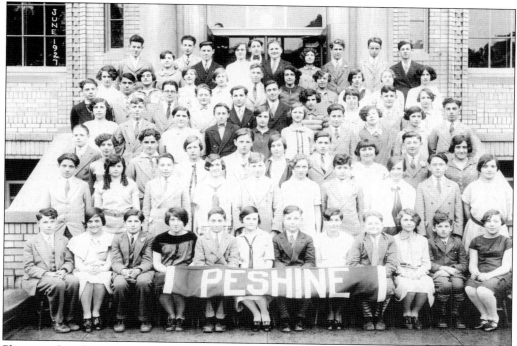

Photographs of Peshine Avenue School graduates date as far back as Howard Straus's class of 1927. (Courtesy Jane Straus Wildstein.)

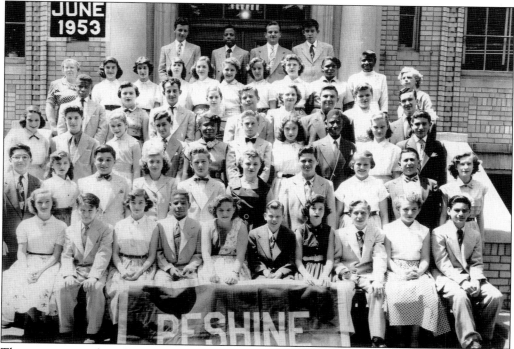

There are, coincidentally, 53 graduates in this 1953 Peshine Avenue School class photograph. (Courtesy Linda Lewin.)

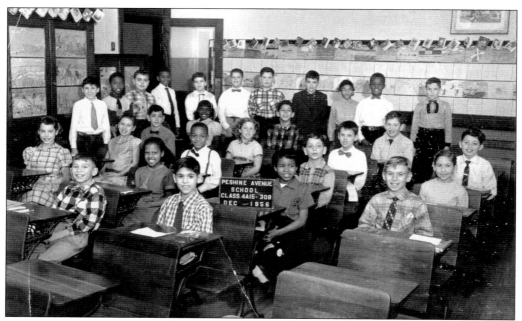

Peshine Avenue graduates Judy Petchesky Unger and Shirley Erzersky Friedman recall their teacher reading *The Hound of the Baskervilles* and other classics. Elaine Canter and Carole Bellows recall the kindergarten teacher feeling the bottoms of her students to see if anyone wet their pants. (Courtesy Phil Yourish.)

Weequahic's elementary school classrooms served as meeting places for adult education and citizenship courses. The textbook on the table to the right of the teacher is titled *Arithmetic for Today*. (Courtesy Weequahic High School Alumni Association.)

Three

LET THE TORCH
BE PASSED
WEEQUAHIC HIGH SCHOOL
FROM 1933 TO 1968

One of Weequahic High School's more thoughtful traditions had graduating seniors passing the torch of school pride and faith in the future to its incoming senior class. (Courtesy Judy Epstein Rothbard.)

Weequahic High School, Newark, N. J.

JULIUS C. BERNSTEIN,
Principal

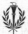

Torch Day Exercises

JUNE, 1958

Let the Torch Be Passed

Before the torch is passed, we pause and hail
 The early founders of this living school,
The pioneers who blazed Weequahic's trail,
 Who kindled flame and then supplied the fuel
Of that eternal lamp that God hath set
 To burn upon this earth, and sea, and sky.
Unlike Prometheus, we hold a trust
 In this gold flame; and we have held it high!

So hath it been, so shall it ever be;
 One light for all that guideth every youth
In his eternal quest for light and truth.
 We, sons and daughters of the living past,
And we, alone, have held this light until
 At last the day has come to hand it on
To those who feel the glow and get the thrill
 Of Senior Day; so let the Torch be passed!

Weequahic High School stands on the site of the home of Chancellor Oliver Spencer Halstead, Newark's fourth mayor. The school opened on September 11, 1933, with an enrollment of 2,056 students and at a construction cost in excess of $1 million. (Courtesy Jewish Historical Society of MetroWest Archives.)

Weequahic High School's art deco style of architecture is reflected in this photograph taken in the lobby around 1933. Viewers can admire details such as the chandelier and design elements on the ceiling and staircase. (Courtesy Weequahic High School Alumni Association.)

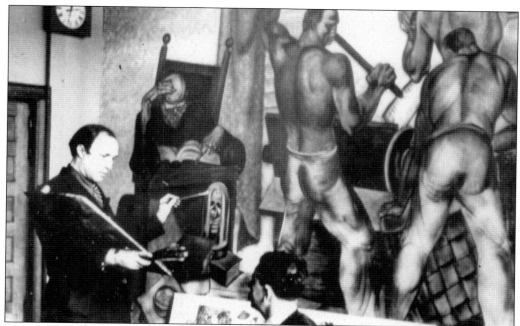

Weequahic is home to one of the most important installations of public art in New Jersey, *History of the Enlightenment of Man*, a New Deal–era mural painted by Michael Lenson, featured left, who was the director of New Jersey mural activities for the Federal Art Project of the Works Progress Administration (WPA). The murals were installed in the lobby of the high school in 1939. (Courtesy Barry Lenson.)

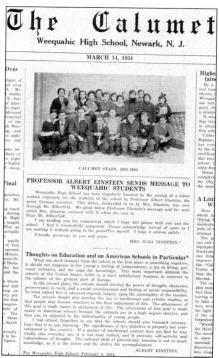

Weequahic High School garnered nationwide attention with the receipt of a letter from world-renowned scientist Prof. Albert Einstein in 1934. The letter was printed in the school's newspaper, the *Calumet*, and 1,300 newspapers around the world. (Courtesy Weequahic High School Alumni Association.)

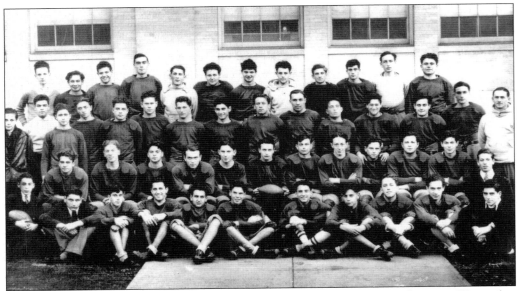

Albert Klein recalls that Weequahic High School's first football contest was between Weequahic and Bayonne High Schools. Weequahic lost. Ken Frieder, Weequahic class of June 1963, recalls that his father, Jake, scored Weequahic's first touchdown in the 1930s, while Richard Trugman, class of 1960, whose father is featured in this photograph, maintains that the first football team was only 11 players and that the first football photograph was taken under the goalpost. (Courtesy Albert Klein.)

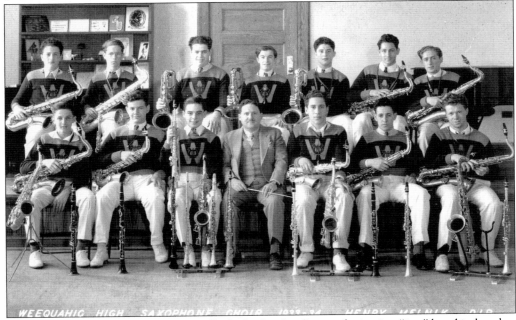

Barbara Rappaport, class of 1966, recalls the high school's award-winning "jazz" band in her day. In the 1930s, it was director Henry Melnik's saxophone choir that won awards. Other musical directors include Frank Scocozza, Vernon Ross, and Michael Page. (Courtesy Weequahic High School Alumni Association.)

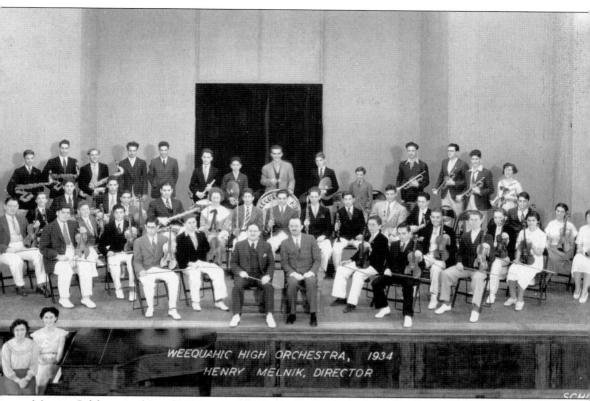

WEEQUAHIC HIGH ORCHESTRA, 1934
HENRY MELNIK, DIRECTOR

Marvin Schlanger, class of 1965, writes, "I remember the band marching onto Untermann Field in a long line, in our orange and brown uniforms to cheers of our fans." The band continues to win honors in both local and national competitions. (Courtesy Weequahic High School Alumni Association.)

Weequahic High School, rated as "one of the most outstanding high schools in the country," had an exceptional faculty. Dr. William Lewin (third from the left) was head of the high school's English department from 1933 to 1955. He was faculty advisor for the school's Photoplay Club and chairman of the motion picture committee of the Department of Secondary Education of the National Education Association. Surely one recognizes Hollywood stars Clark Gable (second from left) and Charles Laughton (right). (Courtesy Linda Lewin and Sandy Mayer.)

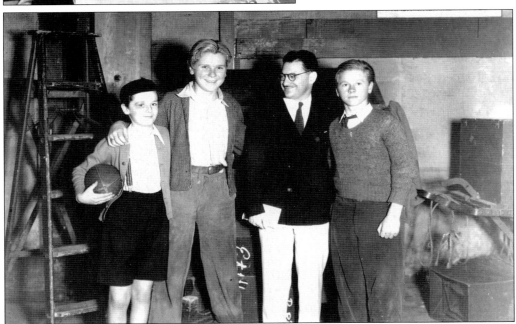

Hollywood stars, from left to right, Freddie Bartholomew, Jackie Cooper, and Mickey Rooney were interviewed by Weequahic's Dr. William Lewin for the film *David Copperfield*. Lewin's parents, Yetta and Marcus, opened an ice-cream store, Lewin's Homemade Ice Cream, in Newark. Ice-cream cones cost 10¢. (Courtesy Linda Lewin and Sandy Mayer.)

The class of 1938 reunion photograph, taken by Ira Sheldon, includes Dorothy Rowe Scott, Seymour "Swede" Masin, Evelyn Reinhard, Bert Manhoff, Jack Rubinfeld, Abraham Dworken, Jerry Lieb, Shirley Rabinowitz, Ruth Maltz Hindlin, and others. (Courtesy Jewish Historical Society of MetroWest Archives.)

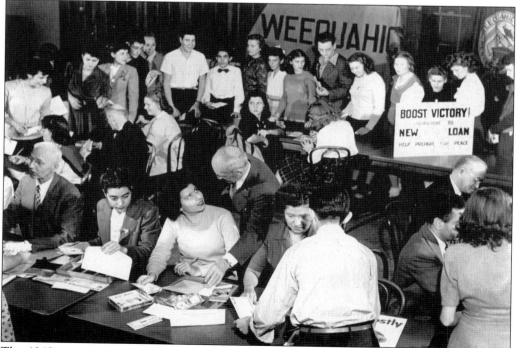

The 1940s were war years. Students and teachers conducted enthusiastic campaigns to raise money to purchase war bonds. (Courtesy Jewish Historical Society of MetroWest Archives.)

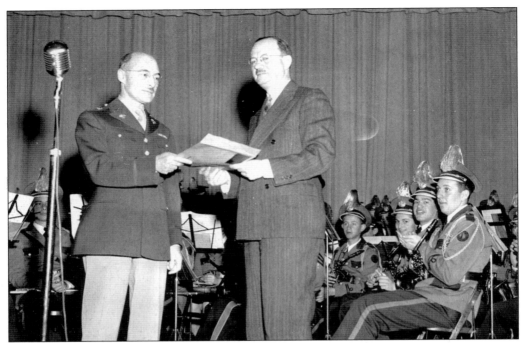

Weequahic principal Max Herzberg (right) is accepting an award for the high school's award-winning orchestra and band in 1944. (Courtesy Weequahic High School Alumni Association.)

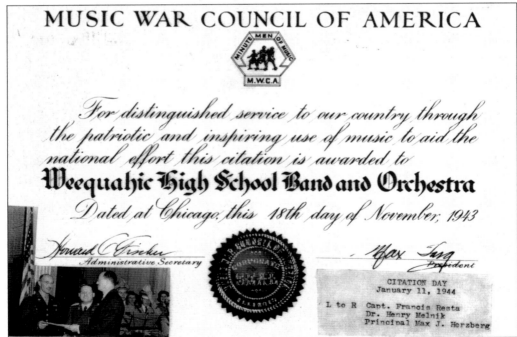

MUSIC WAR COUNCIL OF AMERICA

For distinguished service to our country, through the patriotic and inspiring use of music to aid the national effort this citation is awarded to

Weequahic High School Band and Orchestra

Dated at Chicago, this 18th day of November, 1943

Administrative Secretary

President

CITATION DAY
January 11, 1944

L to R Capt. Francis Resta
Dr. Henry Melnik
Principal Max J. Herzberg

The wartime spirit that pervaded the neighborhood during World War II is reflected in this Music War Council of America award presented to music director Dr. Henry Melnik in 1943. (Courtesy Weequahic High School Alumni Association.)

Seymour "Swede" Masin, class of 1938, attended Maple Avenue School and served as a lieutenant in the United States Navy. A hall of fame athlete, Masin was considered "the best all-round athlete in the school, in Newark, and in New Jersey." The much-admired Masin inspired the character Swede Levov in Philip Roth's Pulitzer Prize–winning novel, *American Pastoral*. (Courtesy Masin family.)

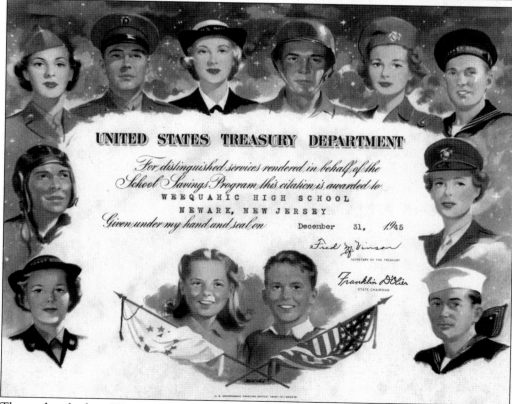

The student body at Weequahic High School was congratulated for its patriotism by the United States Treasury Department in 1945. (Courtesy Weequahic High School Alumni Association.)

45

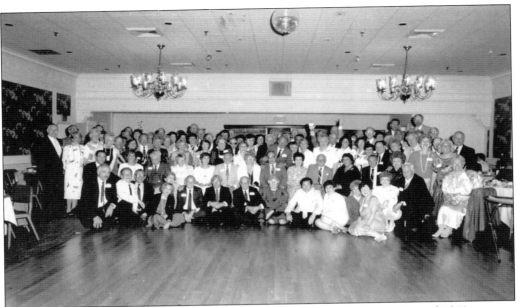

Long-tenured English teacher Hannah Ginsburg Litzky provided this class of 1941 reunion photograph. (Courtesy Jewish Historical Society of MetroWest Archives.)

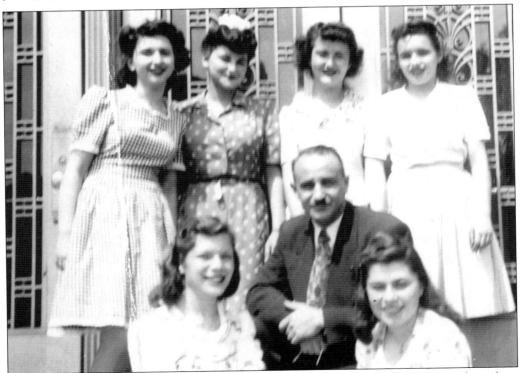

On the front steps of Weequahic High School are members of the class of 1945. Pictured are, from left to right, (first row) Peggy Drill and Selma Tenenbaum; (second row) Claire Golub, Ruth Zucker, Elana Schipper, and Claire Gottlieb. The man is unidentified. (Courtesy Elana Schipper.)

For many years, Weequahic offered more foreign languages—French, Spanish, Latin, German, and Hebrew—than any other high school in the city. This is a Spanish class on the front steps of Weequahic High School in the late 1940s. (Courtesy Judy Blumenfeld Schatzberg.)

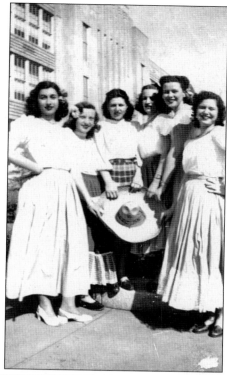

Small dance programs and invitations were distributed to students in their homerooms. These programs are for a 4B hop in 1951 and a 1950 prom. Committee chairs for the prom included Philip Roth, Sanford Goldberg, Herbert Forgash, Alan Clarin, Rolf Kahn, Ruth Staber, Eunice Flicker, Frank Dondershine, and Martin Rosenthal. (Courtesy Gayle B. Jacobs.)

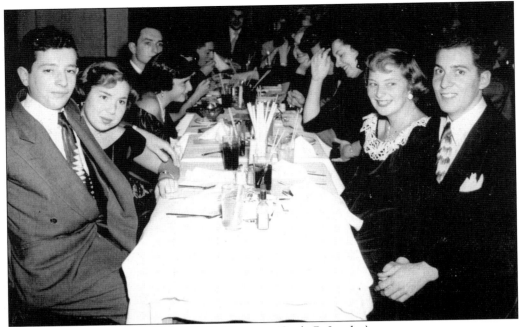

Here is the gang at the 4B hop in 1949. (Courtesy Gayle B. Jacobs.)

This is the news in 1944 from the ninth-grade annex located on Hawthorne Avenue. A second annex was located at Chancellor Avenue School in response to the need for more space at the high school, which happened with an expansion of the building in 1958. (Courtesy Weequahic High School Alumni Association.)

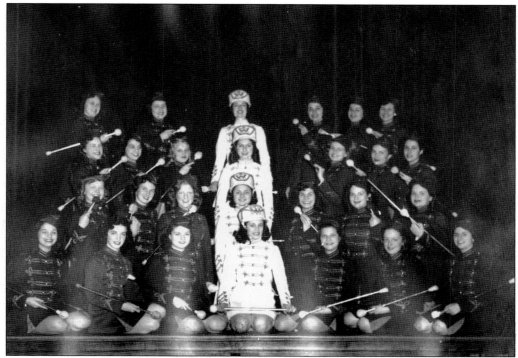

Dressed to march, here are Weequahic High School's twirlers. (Courtesy Marian Fenster.)

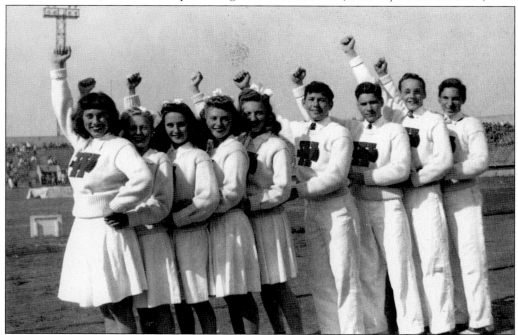

Weequahic's 1942 cheering squad includes, from left to right, Estelle Lepore Masin, Lita Pastalnik, Jane Harris, Beverly Spitalnik, Elayne Stein, Ronny Cohen, Kenny Coleman, Harold Widekehr, and Ivan ?. (Courtesy Masin family.)

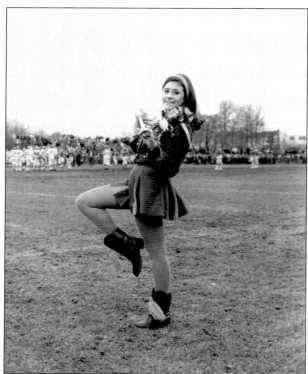

Susan Levine, class of 1965, held on to her twirler's jacket. The jacket is featured in the Jewish Historical Society of MetroWest's exhibition Weequahic Memoirs: Newark's Legendary Neighborhood. (Courtesy Susan Levine.)

One could always count on a full house at Untermann Field when Weequahic High School played its arch football rival Hillside High School for its traditional Thanksgiving Day game. This crowd is attending the 1941 Thanksgiving game. (Courtesy Dr. Kenneth Dollinger.)

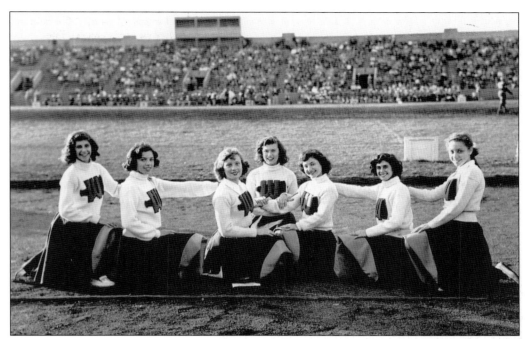

The cheerleading squad at a Weequahic versus West Side High School football game in 1948 includes, from left to right, Elinor Hart, Gladys Stein, Pearl Stein, Helen Kother, Eileen Lerner, Doris Chinsky, and Marlene Ziegler. (Courtesy Eileen Lerner Greenberg.)

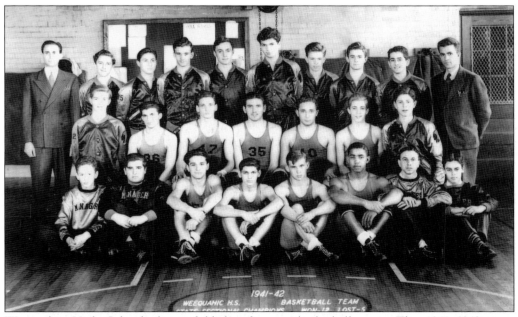

Weequahic High School always fielded a first-rate basketball team. The 1941–1942 team was state sectional champion. Dr. Milton Luria, class of 1939, maintains that Irv Keller was the greatest basketball player of that generation that "we [Weequahic] ever had." (Courtesy Norman Bierbaum.)

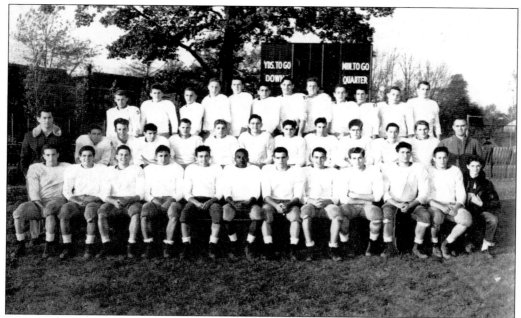

In 1976, Dr. Max Novich, team physician, wrote, no "game can ever replace the fame, glory, personal and community pride generated by the 1951 Weequahic High School football team, who won the city championship under the leadership of head football coach and English teacher Lou Stamelman." (Courtesy Ed Freedman.)

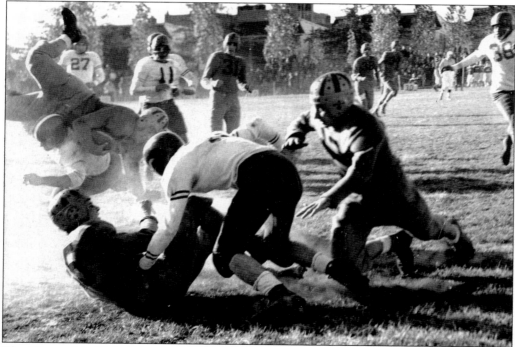

The Weequahic High School football team is seen in action around 1950. (Courtesy Linda Feinblatt Israel.)

The field goal kicker in this photograph is Mickey Dunst, class of 1943. (Courtesy Mickey Dunst.)

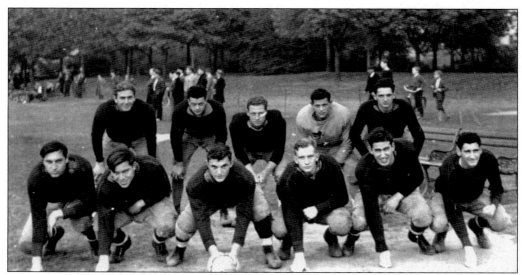

Weequahic's football team for 1937 features, from left to right, (first row) Morris Shrone, Bert R. Manhoff, I. Rothman, unidentified, Bob Olesky, and Shea Schachter; (second row) David Fast, Lester Eagle, Seymour "Swede" Masin, Ed Greenfield, and Seymour "Pep" Pfefferstein. (Courtesy Masin family.)

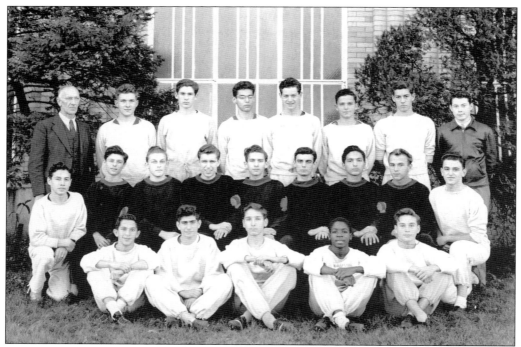

The cross-country team, with 20 runners, placed third in the city championship in 1946. (Courtesy Myron Katz.)

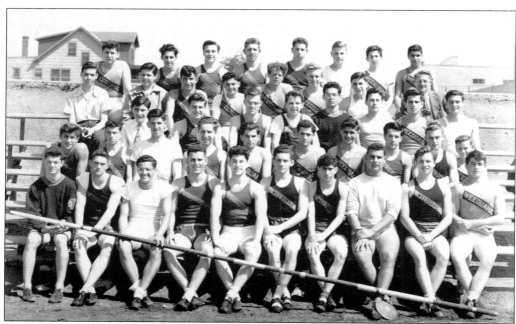

By 1947, Weequahic High School's track team had doubled in size. (Courtesy Myron Katz.)

Weequahic High School

NEWARK **NEW JERSEY**

This certifies that *Harold Heshy Blinder* has satisfactorily completed the four-year *Business* curriculum in this school and has met all the requirements for graduation with the following academic counts:

English	20	General Science	5	Bookkeeping	10	Mechanical Drawing	—
Latin	—	Biological Sciences	5	Stenography	—	Industrial Arts	2½
Modern Languages	—	Physical Sciences	5	Typewriting	2½	Technical Subjects	—
Social Studies	10	Art	1	Office Practice	2½	Home Economics	—
Mathematics	7½	Music	—	Business Subjects	12½	Physical Education & Health	4¾

In testimony whereof we have hereunto set our hands and seal this *Twenty-third* day of *June* A.D. *1943*

Weequahic High School's 1930s and 1940s diplomas took pains to spell out the specific number of credits earned by each student in each subject area. This diploma was signed by Max J. Herzberg, principal of Weequahic High School from 1933 to 1951. Note that the middle name on this diploma reads "Heshy." Heshy might have been the name this student went by during his school years growing up in the Weequahic neighborhood or the Yiddish word for Harold. Some recall that youngsters rarely were known by their given names. There was always a nickname in the mix. (Courtesy Harold Blinder.)

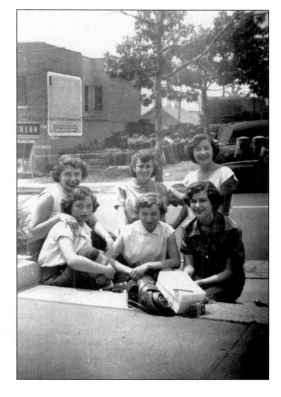

A class picnic includes Roz Dobbin, Rita Birnberg, Judy Manoff, Iris Schwimmer, Barbara Herberg, and Nadella Haskin on the front steps of the high school. (Courtesy Gayle B. Jacobs.)

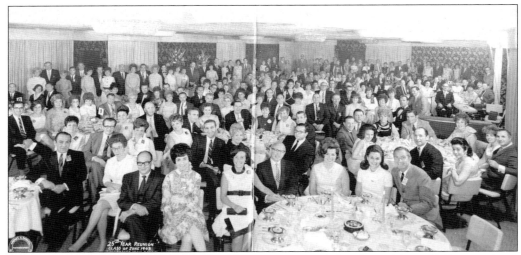

Judging from the large attendance, the 25-year reunion of the class of June 1943 was a huge success. (Courtesy Harold and Carol Kroll Blinder.)

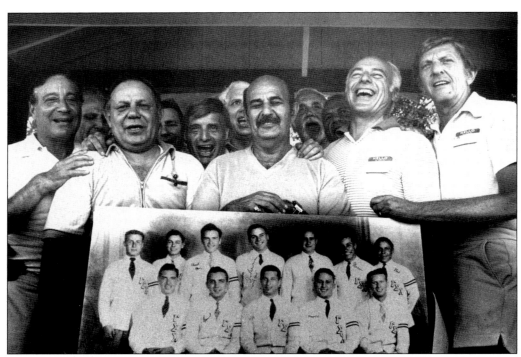

This photograph from 1946 shows 10 Weequahic High School graduates who had recently returned from World War II service. The men were members of Rho Epsilon Sigma national fraternity. (Courtesy Bea and Irving Newman and the Weequahic High School Alumni Association.)

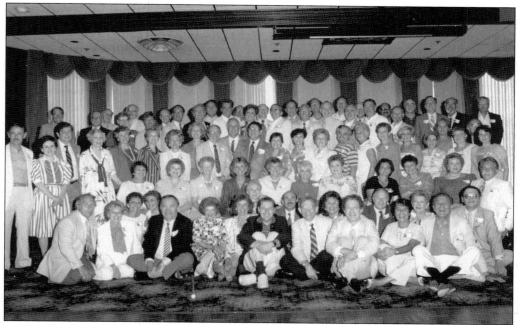

This is the 40th reunion of the class of 1945. The class sponsors an annual academic and performing arts scholarship given to Weequahic High School graduating seniors. The scholarship started in 2002. According to reunion chairman David Horwitz, this is "the largest single class donor towards the high school's scholarship program." (Courtesy David Horwitz.)

Weequahic's native son is the prolific Pulitzer Prize–winning author Philip Roth, class of January 1950. Roth has made Weequahic's neighborhood famous on the pages of American literature, starting in 1959 with the publication of *Goodbye, Columbus*. (Photograph by Nancy Crampton, 2007.)

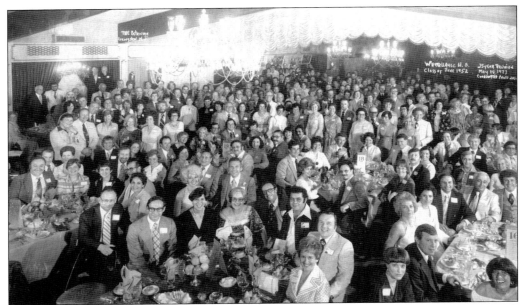

Esther Blaustein Gordon, class of 1952, writes that the graduates featured in this photograph "looked forward to the 4B Hop, a semi-formal in the gym, and then out to a nightclub; in 4A, there were class rings, your yearbook, the class picnic, and of course, the senior prom where you stayed up all night going from house to house and where mothers served you scrambled eggs and orange juice and black coffee." (Courtesy Dr. Noah Chivian.)

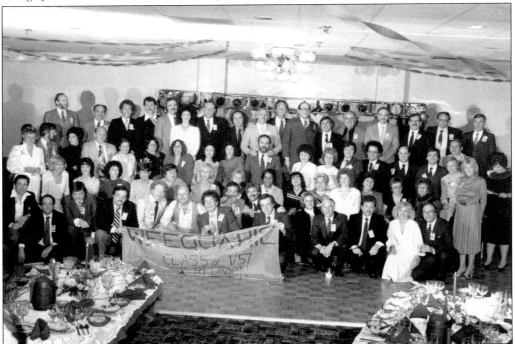

Weequahic graduates from the class of January 1957 turned out in full force for their 25th reunion. (Courtesy Jewish Historical Society of MetroWest Archives.)

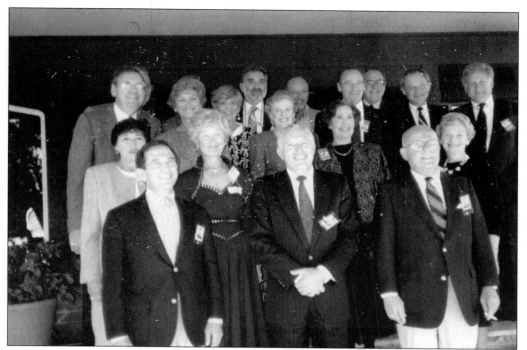

Reunions are the thing. Here are Maple Avenue School graduates attending their 40th Weequahic High School reunion. (Courtesy Norman Krueger.)

WEEQUAHIC HIGH SCHOOL
CHANCELLOR AVE. AND ALDINE ST.

WED. EVE., JAN. 25th, 1956

COMMENCEMENT EXERCISES
ALL SEATS RESERVED
Exercises begin promptly at 8:30 P. M.

It is requested that flowers be not sent to the school.

MAIN FLOOR

PLEASE RETAIN THIS CHECK
INTERNATIONAL TICKET CO. NEWARK, N J

COMMENCEMENT
JANUARY 25, 1956

WEEQUAHIC HIGH

MAIN FLOOR

CENTR

P 108

Lance Posner, *Calumet* photographer, held on to a commencement exercises ticket from 1956. The ticket was printed by International Ticket Company, a business started in Newark in 1898 by the Manshel family. (Courtesy Jewish Historical Society of MetroWest Archives.)

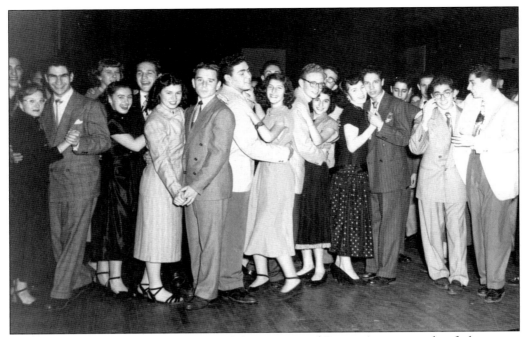

Weequahic High School's students joined the Orange and Brown Association, briefly known as the General Association. The organization sponsored student activities such as this dance held in the 1950s. (Courtesy Weequahic High School Alumni Association.)

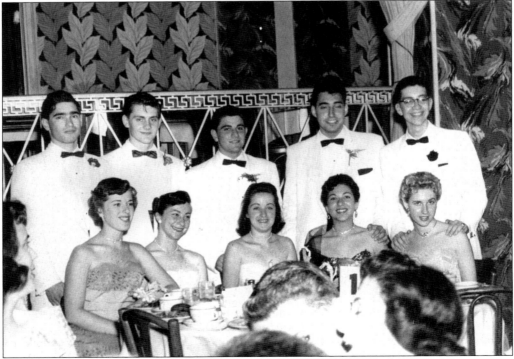

These couples are attending the class of 1955 senior prom. (Courtesy Bob Goldberg.)

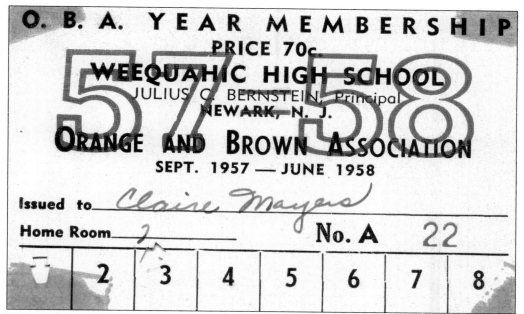

O. B. A. YEAR MEMBERSHIP

PRICE 70c.

WEEQUAHIC HIGH SCHOOL

JULIUS C. BERNSTEIN, Principal

NEWARK, N. J.

ORANGE AND BROWN ASSOCIATION

SEPT. 1957 — JUNE 1958

Issued to Claire Mayers

Home Room 7 No. A 22

	2	3	4	5	6	7	8

Membership cards were issued to each student who joined the high school's Orange and Brown Association. The card was punched to designate attendance at a school event. (Courtesy Claire Mayers Nierenberg.)

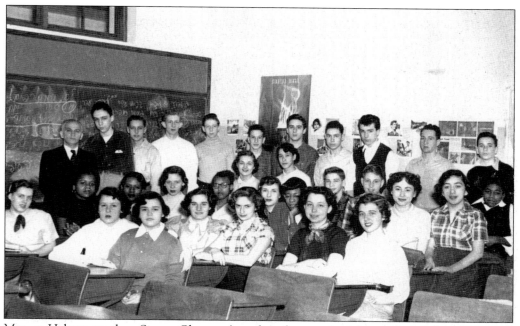

Mar, or Hebrew teacher, Simon Chasen, (standing first on the left) taught Modern Hebrew I. Students recall that Chasen stopped at nothing to make them learn. He rarely uttered a word of English during class. Jewish youngsters outside the Weequahic section requested an opportunity to study Hebrew knowing that it would entitle them to transfer to Weequahic High School. (Courtesy Weequahic High School Alumni Association.)

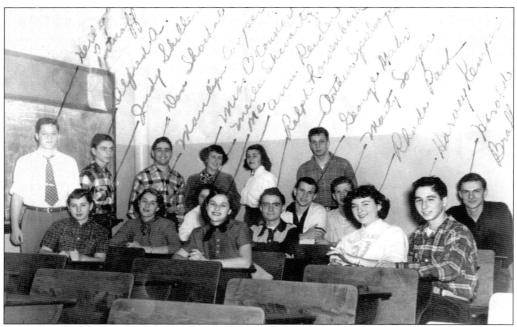

This is Marie O'Connor's special English class in 1951. The student to the far right, Harold Braff, is the copresident and founder of the Weequahic High School Alumni Association. Students recall O'Connor's word of the day. (Courtesy Weequahic High School Alumni Association.)

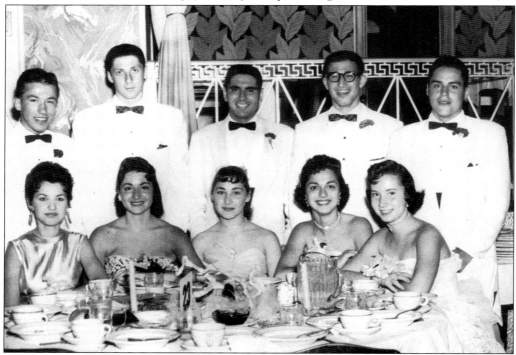

This 1955 senior prom was held at the Terrace Room in the Mosque Theater Building in Newark. (Courtesy Monroe Krichman.)

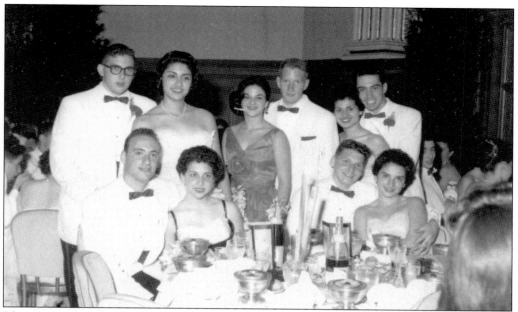

The senior prom for the class of June 1958 was held at the Essex House in Newark. (Courtesy Judy Epstein Rothbard.)

SOUVENIR OF

Frank Dailey's

MEADOWBROOK

Route 23 - - - *Cedar Grove, N. J.*

The Meadowbrook was a popular spot for theater parties and dinners. This souvenir cover is from the early 1950s. (Courtesy Gayle B. Jacobs.)

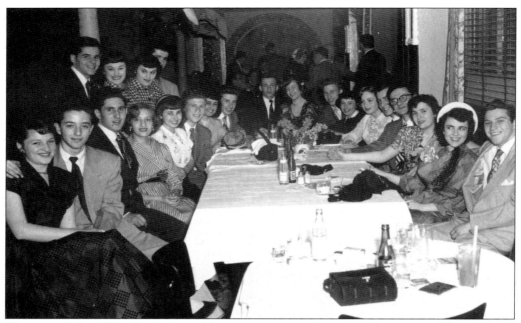

The cast of the 1951 school play celebrates opening night at the Maresque in West Orange. (Courtesy Gayle B. Jacobs.)

Weequahic High School Dramatic Club is rehearsing a scene from *A Happy Journey*. The titles of and photographs from all the school's plays are in the various high school yearbooks. (Courtesy Weequahic High School Alumni Association.)

The cast of school play *Junior Miss* includes Hal Braff, Myron Harkavy, Gil Honigfeld, and Gayle Brody. (Courtesy Gayle B. Jacobs.)

Gym suits and gym classes evoke memories. One can see the name of each student as it appeared on her gym suit. (Courtesy Weequahic High School Alumni Association.)

The school newspaper of record was the *Calumet*. The first edition appeared on December 19, 1933. This staff served in the 1950s. (Courtesy Jewish Historical Society of MetroWest Archives.)

This photograph of a woodworking class and a "Vote for fellow student, Joe Murphy" badge is from the 1950s. (Courtesy of Weequahic High School Alumni Association.)

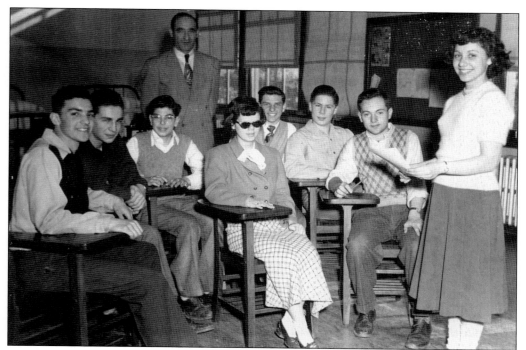

Members of the Orange and Brown Association gather to discuss school activities. (Courtesy Weequahic High School Alumni Association.)

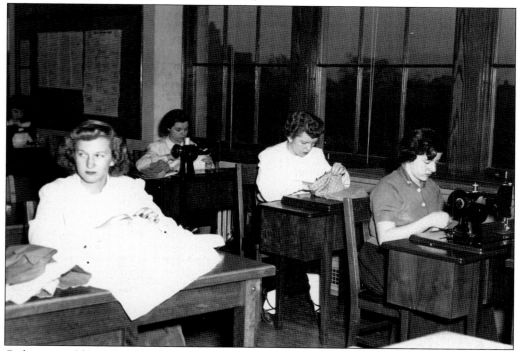

Girls were obligated to take home economics classes. (Courtesy Weequahic High School Alumni Association.)

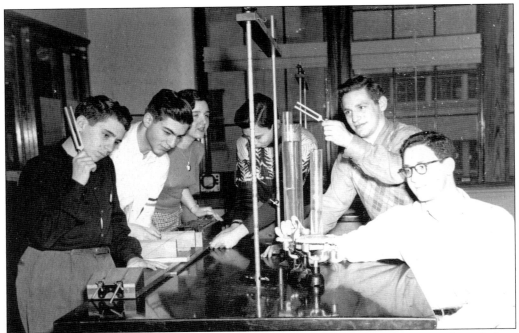

Students "tuned into" science laboratory demonstrations and were encouraged to belong to the school's Thomas A. Edison Science Club. (Courtesy Weequahic High School Alumni Association.)

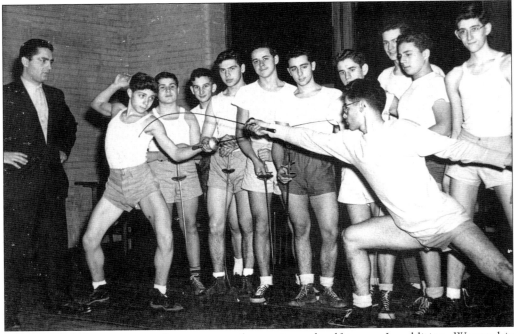

Along with a fencing team, there were track, tennis, and golf teams. In addition, Weequahic High School offered a boxing club, health club, table tennis club, archery club, and trapeze club. (Courtesy Weequahic High School Alumni Association.)

Students were challenged to think by an exceptional group of dedicated teachers. In that vein, Weequahic High School offered a puzzle club, debate club, chess team, Mercury Stamp Club, John A. Logan Honor Society, French Academy, German Table and Spanish and French Clubs, and amateur radio broadcasting club that was heard over WEAF. (Courtesy Weequahic High School Alumni Association.)

A social group, the Starlets continue to keep in touch. Featured at a reunion in 1982 are Berthe Weissman, Rita Blechner, Judy Samwick, Edie Bach, Merle Starkman, Lori Hollander, Riva Geltzeiler, and Marian Braverman. (Courtesy Judy Samwick.)

Certificate of Posture Achievement

AWARDED BY THE BOARD OF EDUCATION
NEWARK, N. J.

TO *MONROE KRICHMAN*

For having successfully passed the POSTURE TEST *B* DIVISION
as prescribed by the Department of Physical Education.

Joseph A Liddy

Director of Physical Education and Recreation

Ira Kanowith

Physical Director

John N. Richards, Sr.

Supervisor of Physical Education

CHANCELLOR AVENUE SCHOOL *School*

Form 52Y

Students in all grades were submitted to an annual posture examination as part of physical education and recreation. (Courtesy Monroe Krichman.)

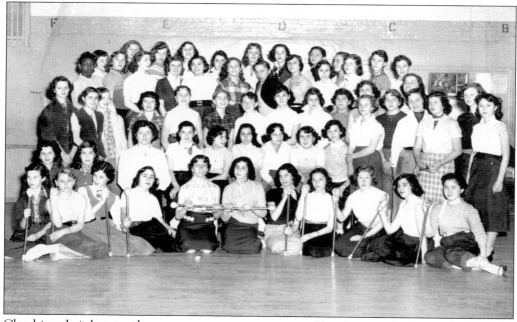

Clutching their batons, these young women were captured by photographer Lance Posner, who attended tryouts for the Weequahic High School twirlers. (Courtesy Jewish Historical Society of MetroWest Archives.)

This windup was captured by *Calumet* newspaper photographer Lance Posner. The pitcher is Fred Simon. (Courtesy Jewish Historical Society of MetroWest Archives.)

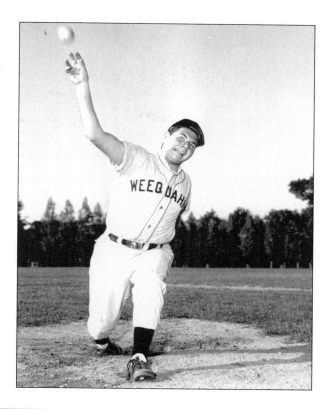

Athletic Association

This is to Certify That

MARVIN FRANK

has been awarded the _____ "W" _____ in _FOOTBALL_
 LETTER SPORT

for the 19 _51_ season

WEEQUAHIC HIGH SCHOOL
 SCHOOL

Louis R. Stamelman Coach _Michael Conovy_ Principal

Marvin Frank received a certificate and W letter as a member of the winning 1951 city football championship season. Lou Stamelman was the coach. Weequahic repeated its city football championships in 1967 and 1968. (Courtesy Dr. Marvin Frank.)

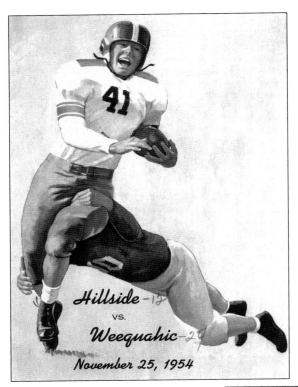

No football game was more spirited than the annual Thanksgiving rivalry between Weequahic and Hillside High Schools. Weequahic, for the most part, was the loser of this fall classic. That is until 1954, when Weequahic, as seen on the cover of this football program, posted a 24-12 victory over its archrival. (Courtesy Eileen Lerner Greenberg.)

The squares contain diagrams of football plays used by Weequahic High School's football team in 1951. Team member Monroe Krichman has held on to the play sheets for more than 50 years. (Courtesy Monroe Krichman.)

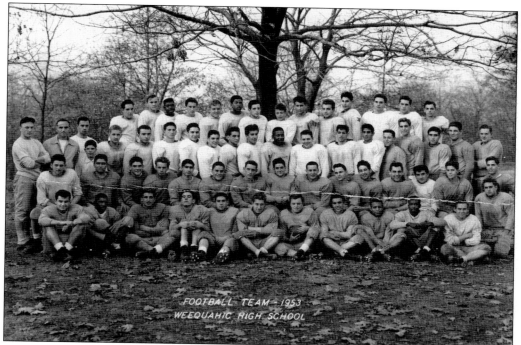

With coach Lou Stamelman calling the plays, quarterbacks Monroe Krichman and Richie Roberts ran Weequahic's 1953 football team. (Courtesy Monroe Krichman.)

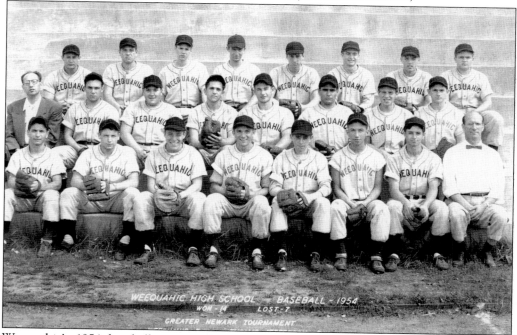

Weequahic's 1954 baseball team posted a winning season of 14-7. The same year, Paul Trachtenberg, known as "Yogi" to his classmates, pitched a one-hitter to beat South Side High School. (Courtesy Monroe Krichman.)

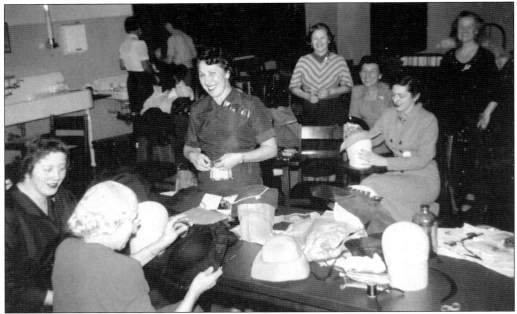

As many as 60 course selections over the course of 42 years were offered by Weequahic Adult School, including millinery (hat-making) classes, opportunities to study the international language Esperanto, and gun safety through education, which was sponsored by the National Rifle Association. (Courtesy Weequahic High School Alumni Association.)

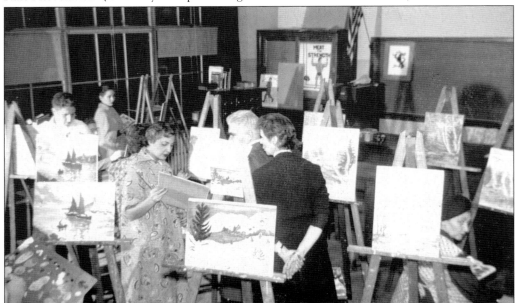

This class of amateur painters met at Weequahic Adult School. In the 1950s, Morton Seltzer, head of Weequahic's math department, was chairman of the adult school. "Waldo Winchell," a popular column in the alumni *Calumet*, recalls that Dorothy Scott Rowe, class of 1938, was the first graduate of Weequahic High School to become the director of the Weequahic Adult School. (Courtesy Weequahic High School Alumni Association.)

Twins Jac (right) and Norbert Toporek are from the class of 1963. Jac distributes a weekly e-mail newsletter that reaches several thousand Weequahic High School graduates. The newsletter contains memories sent to Jac from all over the country that recall growing up in the neighborhood. (Courtesy Jac Toporek.)

Baseball legends Monroe Krichman (left) and Paul Trachtenberg have been friends off the field for more than 50 years. (Courtesy Weequahic High School Alumni Association.)

Class of 1948 graduates have kept ties for more than 60 years. (Courtesy Diane Newmark Denberg.)

Hail to the members of Weequahic's 1960s and early-1970s faculty. (Courtesy Lester Fusco.)

With arms around his English teacher Hilda Lutzke, Weequahic sports legend and NBA star Alvin Attles is enjoying an alumni scholarship dinner in 2006. (Courtesy Weequahic High School Alumni Association.)

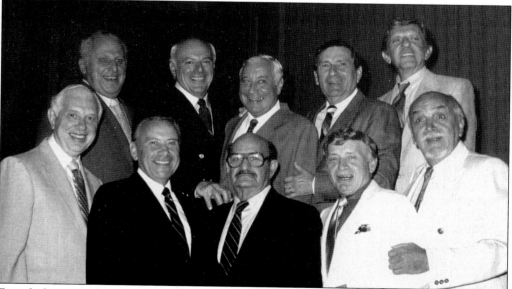

Friends for more than 70 years, this group gets together frequently. From left to right are (first row) Milt Cooper, Dan Klein, Seymour Alfscheler, Jack Kamm, and Norman Aronchick; (second row) Mort Rosenstein, Irv Newman, Marv Tinsky, Milt Frieder, and Monroe Greene. This photograph was taken at Kutsher's Hotel in 1990. (Courtesy Weequahic High School Alumni Association and Bea and Irv Newman.)

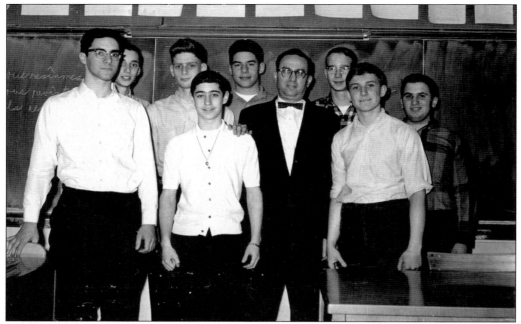

Morton Seltzer's 1962 math team includes Sam Mayer, Eric Weisman, Arthur Lubin, Isadore Strauss, Ira Feinberg, Daniel Mintz, William Rabinowitz, and Michael Barr. (Courtesy Jewish Historical Society of MetroWest Archives.)

Weequahic High School was known for its outstanding basketball teams. (Courtesy Weequahic High School Alumni Association.)

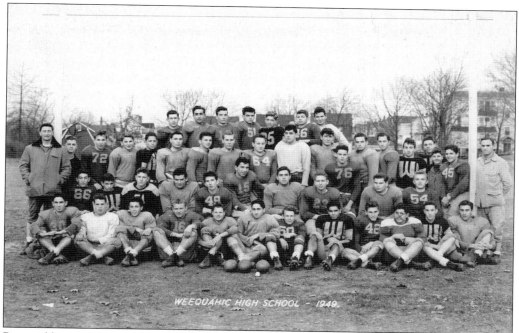

Pictured here is Weequahic's 1949 football team. (Courtesy Linda Feinblatt Israel.)

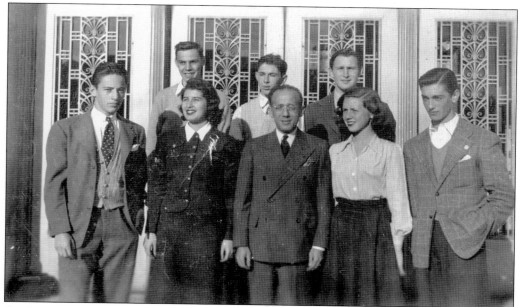

On the steps of Weequahic High School in the 1940s are Orange and Brown Association Council student representatives. From left to right are (first row) Irwin Lieb, Myra Sklary, advisor A. W. Ackerman, Lenora Chaice, and Stan Cutler; (second row) Ben Perlmutter, Richard Drill, and Sy Santlifer. (Courtesy Ben Perlmutter.)

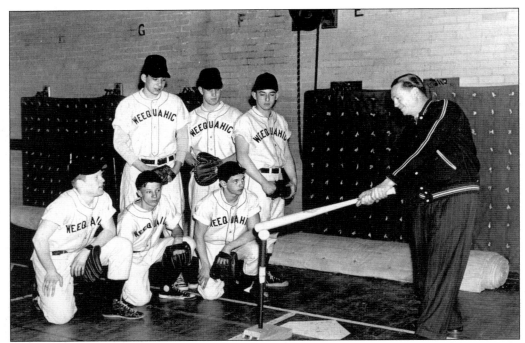

Art Lustig is the coach, and the name of the game is baseball. "Mr. Lustig will be missed," appeared in a 1977 *Star Ledger* article regarding his role as a Weequahic High School coach. (Courtesy Linda Feinblatt Israel.)

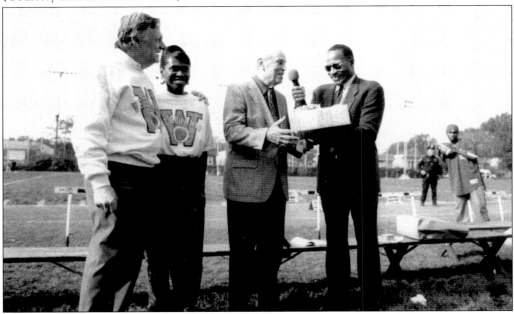

Alumnus Sid Dorfman (third from the left), "dean" of New Jersey sportswriters, is honored at a Weequahic homecoming football game. He is flanked by alumni association president Hal Braff (left), alumni association board member Adelah Quddus, and former Newark mayor Sharpe James (right). (Courtesy Weequahic High School Alumni Association.)

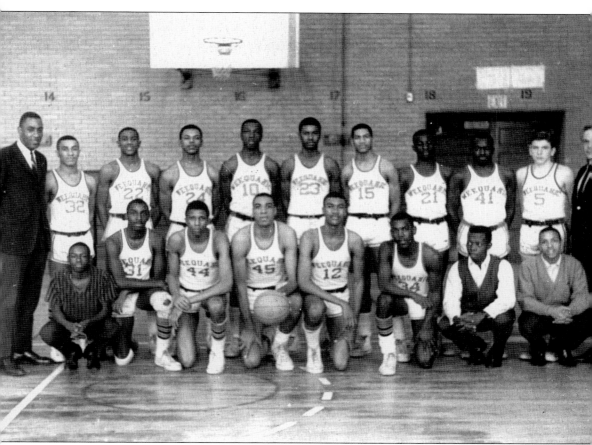

Coach Les Fein's 1966–1967 team, with its amazing 27-0 record, was rated the No. 1 public school basketball team in the nation. At the end of Fein's 12-year career, he had a 210-69 record and a .753 winning percentage to his credit. The team was city, Holiday Festival, county, North Jersey, and state champions at this time. Pictured are (first row) assistant manager Mark Little, Bill Mainor, Leroy Cobb, Dana Lewis, George Watson, Dennis Layton, manager Martin Davis, and assistant manager Marcus Hinton; (second row) assistant coach Seth Hicks, Dennis Mosley, Frank Summerfield, Richie McLeod, Harold Morrell, Phil Hickson, Lucius Childs, James Randolph, Harold Hooper, Gerry Gimbelstob, and coach Les Fein. (Courtesy Fein family.)

Weequahic High School's remarkable history appears on the pages of its yearbook, the *Legend*. This issue features the school logo on its cover. The Weequahic High School Alumni Association has a full run of the school's yearbooks starting in 1933 and going forward. (Courtesy Lester Fusco.)

Four

THE GREAT HOT DOG DEBATE
SHOPS, STOPS, AND EATERIES

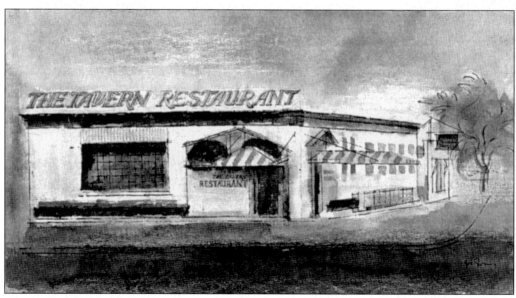

Alas, only a postcard image remains to remind people of Sam Teiger's popular Tavern Restaurant when it was located at 444 Elizabeth Avenue adjacent to Weequahic Park. Newark historian Nat Bodian recalls that "for thirty years to the end of the 1950s, the food and service [provided by the Tavern Restaurant] was unmatched by any other eating establishment in New Jersey." Among restaurants it was ranked 25th nationally. Now there is an apartment building on the site. (Courtesy Jewish Historical Society of MetroWest Archives.)

The Tavern Restaurant was one of the nation's finest. Its specialty, coconut cream pie, made a lasting impression on former New York mayor Ed Koch. Koch grew up in Newark. The recipe was reprinted in the Weequahic High School Alumni Association's newsletter, the *Calumet*. (Courtesy Weequahic High School Alumni Association.)

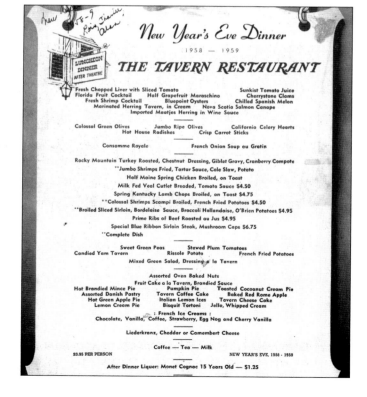

This Tavern Restaurant menu is from New Year's Eve 1958. (Courtesy Jewish Historical Society of MetroWest Archives.)

A Saturday night date was probably capped off with a piece of cheesecake at the Weequahic Diner, built in 1938. Owners Leo and Morris Bauman promoted the diner as "New Jersey's Largest and Most Beautiful Air Conditioned Diner Located in the Heart of Newark." (Courtesy Jewish Historical Society of MetroWest Archives.)

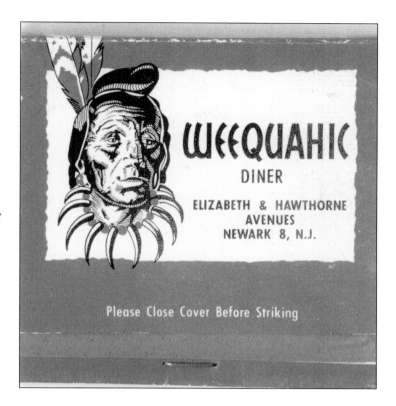

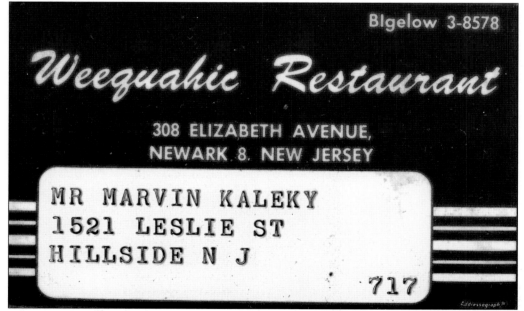

Florida resident Marvin Kaleky held on to this "credit" card for more than 50 years. (Courtesy Marvin Kaleky.)

Here is a page from the Weequahic Diner's dairy menu. Cholesterol was not "invented" in the diner's heyday. Patrons were advised that all orders were either panfried or baked in butter and served with extra-heavy sour cream. (Courtesy Sheldon Bross.)

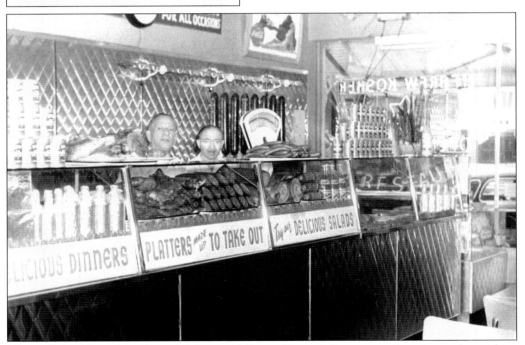

OUR FAMOUS DAIRY SALADS and FISH DINNER DELICACIES

SOUP OF THE DAY

APPETIZERS

Matjes Herring in Wine Sauce	Fruit Cocktail	Schmaltz Herring
Chopped Liver	Chopped Egg and Onion	Stuffed Kishka
Marinated Herring	Homemade Gefilte Fish	Half Grapefruit
	Fresh Crabmeat Cocktail	

	Plate	Complete
3 GOLDEN BROWN POTATO BLINTZES	.75	1.50
3 GOLDEN BROWN CHEESE OR CHERRY BLINTZES	.85	1.60
3 GOLDEN BROWN FRESH BLUEBERRY BLINTZES	.85	1.60
3 GOLDEN BROWN PINEAPPLE CHEESE BLINTZES	.85	1.60
3 GOLDEN BROWN FRESH STRAWBERRY BLINTZES	.90	1.65
3 GOLDEN BROWN POTATO PANCAKES, HOMEMADE APPLE SAUCE OR SOUR CREAM	.75	1.50
FRESH STRAWBERRIES WITH EXTRA HEAVY SOUR CREAM	.90	1.65
GARDEN VEGETABLES AND POT CHEESE WITH EXTRA HEAVY SOUR CREAM	.80	1.55
WHOLE JUMBO SHRIMP SALAD PLATE, LETTUCE, TOMATO, POTATO SALAD, COCKTAIL SAUCE	1.45	2.20
WHOLE BUMBLE BEE SALMON SALAD PLATTER, LETTUCE, TOMATO, HARD BOILED EGG, POTATO SALAD	1.20	1.95
NOVA SCOTIA SALMON AND CREAM CHEESE PLATTER, SLICED BERMUDA ONION, LETTUCE, TOMATO, Potato Salad	1.25	2.00
SMOKED WHITE FISH, NOVA SCOTIA SALMON, Cream Cheese Sliced Tomato, Bermuda Onion, Potato Salad	1.55	2.30
IMPORTED SKINLESS AND BONELESS PORTUGESE SARDINES, Hard Boiled Egg Quarters, Tomato Sliced	1.35	2.10
FRIGID LOBSTER SALAD BOWL, LETTUCE, TOMATO, AND EGG QUARTERS	1.50	2.25
CHICKEN SALAD, PLATTER, LETTUCE, TOMATO, POTATO SALAD, HARD BOILED EGG	1.20	1.95
CHOPPED LIVER SALAD PLATTER, LETTUCE, TOMATO, Potato Salad, Bermuda Onion	1.20	1.95
TROPICAL HEALTH PLATTER, CREAMY COTTAGE CHEESE with a Variety of Fresh Cut Fruits Served Over Crispy Lettuce with Sour Cream Dressing	1.20	1.95
PINEAPPLE SHOWBOAT: HALF JUMBO PINEAPPLE FILLED WITH PINEAPPLE SECTIONS and Fresh Mixed Fruits Topped with Fresh Creamy Cottage Cheese, Sour Cream Dressing	1.25	2.00
HALF BOILED COLD SPRING CHICKEN, Lettuce, Tomato, Potato Salad, Homemade Apple Sauce	1.75	2.50
ASSORTED COLD CUTS, LETTUCE, TOMATO, POTATO SALAD, CHEF'S SALAD BOWL	1.50	2.25
COLD ROAST JUMBO TURKEY DRUM STICK, CRANBERRY SAUCE, Potato Salad, Chef's Salad Bowl	1.95	2.60
COLD JUMBO LOBSTER TAIL (ONE) LETTUCE, TOMATO, POTATO SALAD, Cocktail Sauce	1.95	2.65
OUR OWN HOMEMADE GEFULTE FISH SALAD, Red Beet Horseradish, Lettuce, Tomato, Potato Salad	1.25	2.00

ALL ABOVE ORDERS PAN FRIED OR BAKED IN PURE CREAMY BUTTER AND SERVED WITH EXTRA HEAVY SOUR CREAM.

CHEF'S SALAD AND ROLLS, BUTTER

Chocolate Eclair	Chocolate, Coconut or Banana Cream Pie		
Jello	Danish Pastry	Ice Cream	Rice Pudding
Half Grapefruit 20	Baked Apple .25	French Pastry	

Morris Rosenblum (standing right) owned Eppes Essen delicatessen when it was located on Hawthorne Avenue in the 1950s. Eppes Essen relocated to Livingston where it continues to be a popular eatery with former Weequahic residents. (Courtesy Elliott Sudler.)

Newark's longest street, Bergen Street, was the shopping mecca for Weequahic residents primarily in the 1940s and 1950s. Jewish merchants belonged to the Bergen Street Merchants Association and advertised in the *Jewish News*. As the population shifted during the 1960s, several of Bergen Street's merchants opened stores in towns located in Essex County's suburbs. (Courtesy Jewish Historical Society of MetroWest Archives.)

Along with its merchants, Bergen Street was home to the Park movie theater that attracted area school-age children for its Friday night and Saturday matinee performances. Note that the logo for the merchant's association was the Weequahic Indian. (Courtesy Jewish Historical Society of MetroWest Archives.)

88

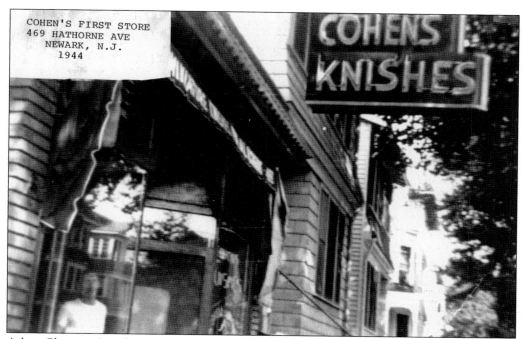

COHEN'S FIRST STORE
469 HATHORNE AVE
NEWARK, N.J.
1944

Arlene Chausner Swirsky and Dennis Estis recall the knishes, hot dogs, fries on small wooden spears, and jelly apples given out at Halloween at Cohen's restaurant when it was located at 469 Hawthorne Avenue near the Weequahic School Annex. (Courtesy Barbara and Ed Cohen.)

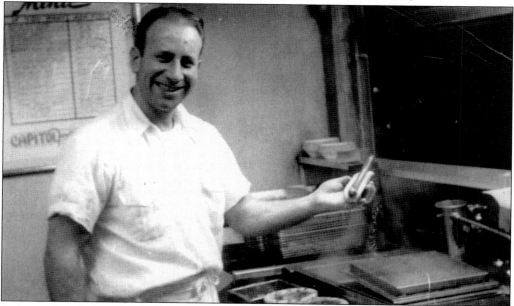

Syd's was founded in 1941 by Syd Goldstein and was sold in 1947 to Mort Bratter, who is featured in this photograph. Located on Chancellor Avenue across the street from Weequahic High, Syd's was *the* destination for hot dog lovers. That is, unless one was a fan of hot dogs at Millmans or Sabins or the Hot Dog Haven or the Bunny Hop. Syd's advertised in the high school newspaper. The slogan was "Built for Weequahic by Weequahic." (Courtesy Dr. Paul Bratter.)

A series of mom-and-pop stores dotted the neighborhood. This produce market was located on Keer Avenue next to the local butcher and just around the corner from Belfer's Luncheonette. (Courtesy Sandy Miller Citron.)

Stein's Dry Goods was located at 1063 Bergen Street. Featured is Pearl Stein babysitting for Barbara Steinberg, whose parents owned the candy store next door. (Courtesy Elayne Lite.)

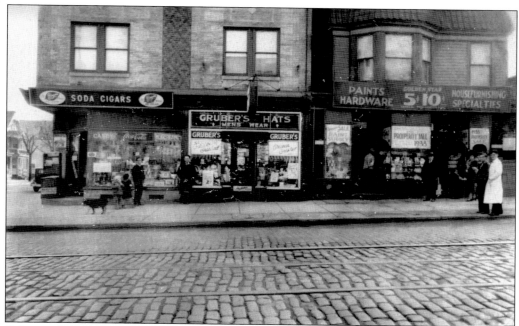

Solomon Poll and his son, Isidore, owned a confectionery store at the corner of Peshine and Clinton Avenues in Newark. The year of the photograph is 1933. (Courtesy Harold Kravis.)

Weequahic was home to a Talmud Torah, or Hebrew school, and a number of Orthodox synagogues. There were numerous choices to eat out if one kept a kosher home, as this list of kosher caterers indicates. (Courtesy Jewish Historical Society of MetroWest Archives.)

Conduct Your Functions

IN ACCORDANCE WITH DIETARY LAWS
DON'T MISLEAD YOUR GUESTS.

KEEP YOUR CONSCIENCE CLEAR
CELEBRATE YOUR JOYOUS OCCASIONS IN PLACES
WHERE DIETARY LAWS ARE OBSERVED
The following catering establishments are under constant supervision of the proper authorities:

ALPINE MANOR
444-446 CLINTON AVE. — Tel. BIgelow 3-0480

ANN GORDON, Inc.
25-27 ELIZABETH AVE. — Tel. BIgelow 2-9820

CLINTON MANOR
104 CLINTON AVE. — Tel. BIgelow 3-8039

CONTINENTAL CATERERS
982 BROAD ST. — Tel. MItchell 2-9751

ESSEX HOUSE
1050 BROAD ST. — Tel. MItchell 2-4400
Dietary Catering on Request

STEINER'S
709 CLINTON AVE. — Tel. ESsex 2-7474

TUNIS MANSION
933 BERGEN ST. — Tel. WAverly 3-9551

Rabbi Louis Weller · *Rabbi Charles Glatzer*

Nettie Farber (née Zimmerman) opened a millinery shop at 1009 Bergen Street. A line of costume jewelry was added as her husband, David, was a costume jeweler. The store remained in its original location through 1980 in a building, it is believed, that was owned by Abner "Longy" Zwillman. (Courtesy Jordan and Gary Feldman.)

Jelling's was located on the corner of Clinton Avenue and Bergen Street, kitty-corner to the Wheelbarrow Bar and across from Whelan's drugstore. Myrna Jelling Weissman recalls how her grandfather David Jelling taught the children of the family how to roll cigars and to check for worms in the tobacco. (Courtesy Myrna Jelling Weissman.)

Ida and Harry Lehr owned a candy store on Bergen Street in 1945. Eventually they converted the store to a specialty shop selling cigars, perfumes, and small leather goods and offered social printing. The couple purchased the building seen in this photograph in 1950 and retired in 1972. (Courtesy Edwin W. Lehr.)

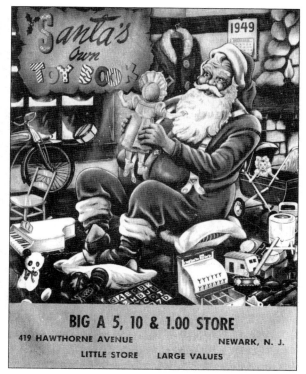

Allan C. Kane and his wife, Rae, returned to Newark after serving in the military in the Philippines during World War II and opened the Big A, a five-and-dime store on Hawthorne Avenue. (Courtesy Allan C. and Rae Kane.)

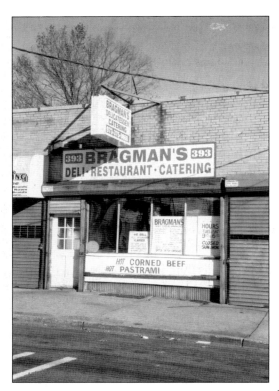

Originally located at 417 Hawthorne Avenue, Bragman's moved a few doors down to 393 Hawthorne in 1962. The Reisner family purchased the store from Abe Bragman in 1951. Bragman's is the last delicatessen in Weequahic and is still serving Jewish-style cuisine. (Courtesy Reisner family.)

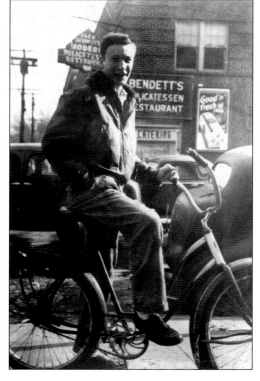

Sheldon Belfer is on his bicycle at the corner of Lyons Avenue and Wainwright Street. Belfer's Luncheonette was where one former resident recalled patrons could order the best egg salad sandwich in the world. Other small eateries requiring mention include the 3H's (Halems, Harjays, and Hatoffs), Tabatchnick's on Bergen Street, and Watson's Bagels on Clinton Place, which, according to Bruce Rosenthal, achieved the "national standard by which all bagels [were] held up to." (Courtesy Sheldon Belfer.)

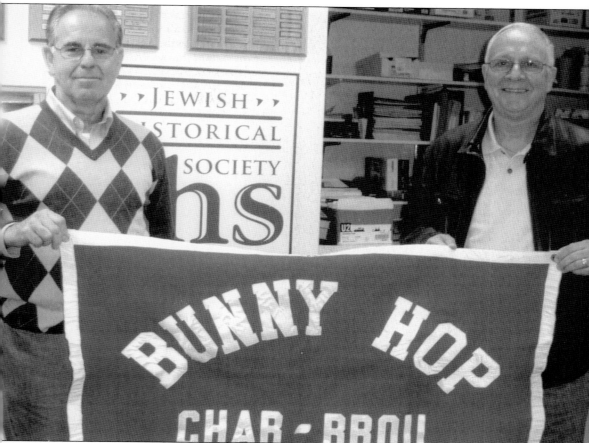

Jerry Trugman and Jeffrey Goldman were owners of the Bunny Hop. Both men are graduates of Weequahic High School, class of 1960. The first Bunny Hop restaurant opened in 1958 on Chancellor Avenue and was owned by Jerry Peterman and Morton "Bunny" Zimmer, two brothers-in-law. The banner signified the start of each Little League season, of which the Bunny Hop was a proud sponsor of a team from the Chancellor Avenue grammar school. (Courtesy Sheri and Richard Trugman and Jeffrey Gelman.)

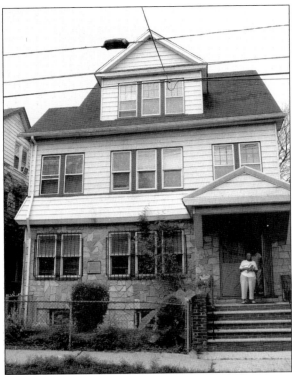

This house is located on Summit Avenue. The current residents are used to curiosity seekers who stop by, knock on the door, and ask to see where noted author Philip Roth grew up. (Courtesy Robert Wiener and *New Jersey Jewish News*.)

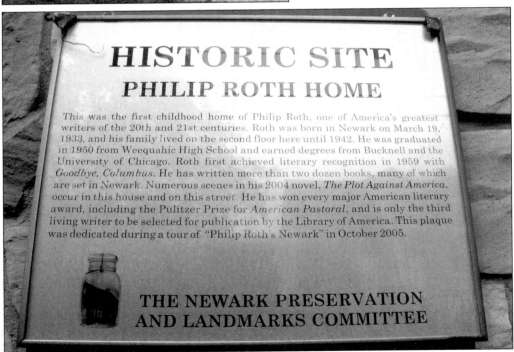

HISTORIC SITE
PHILIP ROTH HOME

This was the first childhood home of Philip Roth, one of America's greatest writers of the 20th and 21st centuries. Roth was born in Newark on March 19, 1933, and his family lived on the second floor here until 1942. He was graduated in 1950 from Weequahic High School and earned degrees from Bucknell and the University of Chicago. Roth first achieved literary recognition in 1959 with *Goodbye, Columbus*. He has written more than two dozen books, many of which are set in Newark. Numerous scenes in his 2004 novel, *The Plot Against America*, occur in this house and on this street. He has won every major American literary award, including the Pulitzer Prize for *American Pastoral*, and is only the third living writer to be selected for publication by the Library of America. This plaque was dedicated during a tour of "Philip Roth's Newark" in October 2005.

THE NEWARK PRESERVATION
AND LANDMARKS COMMITTEE

The initiative to make Philip Roth's home a historic site in 2005 is the result of the efforts of the Newark Preservation and Landmarks Committee. (Courtesy Robert Wiener.)

ROBIN HOOD'S MERRY BAND

CERTIFICATE OF AWARD

Be It Hereby Known — That

Jane Straus 5B M

has achieved a target score of __15__ books

Date _Sept. 10, 1956_ Signed _Florence Addison_

Children's Librarian

CHILDREN'S DIVISION

NEWARK PUBLIC LIBRARY

Certificates of achievement were awarded to youngsters who participated in a summertime reading program sponsored by the children's division of the Newark Public Library when it had a Weequahic branch on Osborne Terrace. (Courtesy Jane S. Wildstein.)

Hansbury Avenue, never more beautiful than in this Saul Schaeffer painting done in the summer of 1962, reflects the plans of Frank J. Bock, principal developer who gave the name Weequahic to this section of Newark. (Courtesy Robert Schaeffer.)

Weequahic's youngsters took dance lessons at Lippel's School of Dancing and participated in its annual recitals. Lippel's had the distinction of being the second-oldest dance school of its kind in the nation, starting in 1894. (Courtesy Jewish Historical Society of MetroWest Archives.)

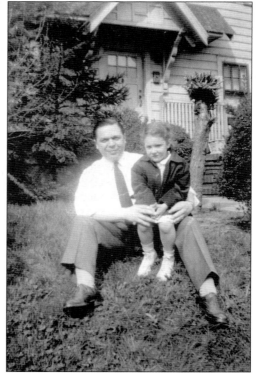

Weequahic's tree-lined streets had modest frame houses with redbrick stoops, gabled rooflines, and small front yards. The Zimmerman family lived at 267 Vassar Avenue. Featured are Jacob Zimmerman and daughter Linda. (Courtesy Linda Z. Willner.)

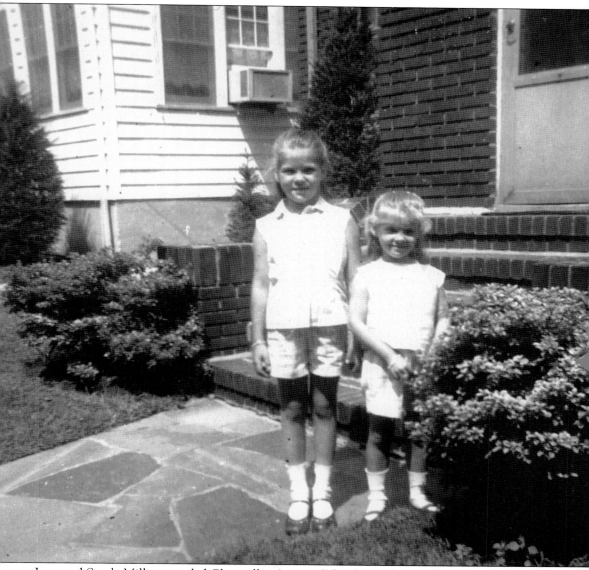

Joan and Sandy Miller attended Chancellor Avenue School and played ball on the front stoop of their family home on Keer Avenue. (Courtesy Sandy Miller Citron.)

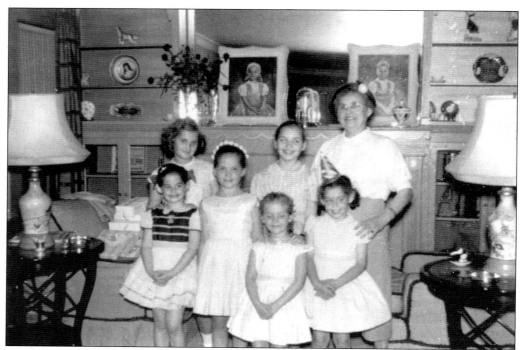

The Miller cousins are assembled for a family birthday party. (Courtesy Sandy Miller Citron.)

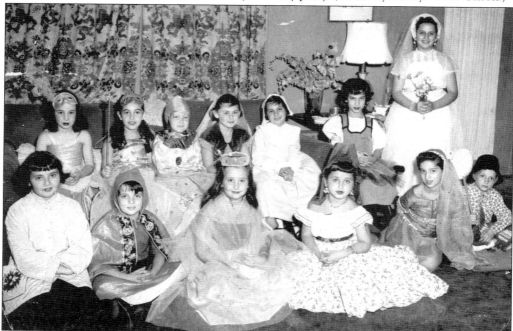

Miriam Rosenberg's house was the meeting place for this 1955 Halloween party. Attending are, from left to right, (first row) Lorraine Glass, Irene Gottesman, Sandy Pfeffer, Jane Straus Wildstein, and Marsha Morris; (second row) Susan Kaiser, Andrea Krech, Nora and Miriam Rosenberg, Carolyn Blum, Julie Untermann, and Carol Strauss. (Courtesy Jane S. Wildstein.)

Class of 1955 graduate Joan Glassman captures the mood of America in the 1950s. Class of 1958 graduate anthropologist Sherry B. Ortner chronicled the journey of the upward mobility of her 1950s-generation classmates from modest working- and middle-class backgrounds into the affluent upper-middle and professional/managerial classes. Joan is somewhere in the Weequahic neighborhood posing on her father's Oldsmobile. (Courtesy Joan Glassman.)

Hal Morgan is featured at Morgan's Luncheonette, which was located on Hawthorne Avenue near the Weequahic Annex in 1949. (Courtesy Gayle B. Jacobs.)

The summer of 1948 shows Vic and Vince in front of Leeds Drugstore when it was located on the corner of Chancellor Avenue and Wainwright Street. The boys worked at the soda fountain. (Courtesy Gayle B. Jacobs.)

Five

THE ENDURING COMMUNITY
SYNAGOGUES, THE Y, AND OTHER NEIGHBORHOOD ACTIVITIES

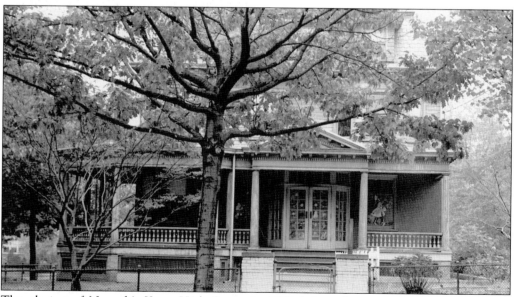

The closing of Newark's Y on High Street in 1954 led to the opening of this makeshift Y located at 128 Chancellor Avenue at the corner of Parkview Terrace. Another house on Goodwin Avenue was used for administrative purposes. (Courtesy Jewish Historical Society of MetroWest Archives.)

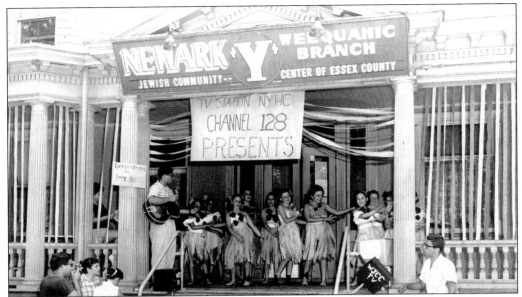

This is the closing day program for parents whose children attended the Y's Home Camp Program. Michael Kessler, Weequahic High School class of 1960, writes, "Does anyone remember all those nights of dancing and congregating at the old 'Y' building on Chancellor Avenue. I recall hundreds of kids on one or two weekday nights at the old house with the big porch dancing during the era of American Bandstand." (Courtesy Jewish Historical Society of MetroWest Archives.)

A dance celebrating the second anniversary of the Weequahic Y in 1954 is an indication of the Y's success. In fact, the Weequahic Y was so successful that it actually had a waiting list of people wanting to join. The Y's director went so far as to say that "we have repeated evidence of families that have indicated that they no longer have to flee Newark." (Courtesy Jewish Historical Society of MetroWest Archives.)

In 1959, the Chancellor Avenue Y opened to serve some 35,000 Weequahic, Irvington, and Hillside residents. The chairman of the building committee was Meyer Lowy. (Courtesy Jewish Historical Society of MetroWest Archives.)

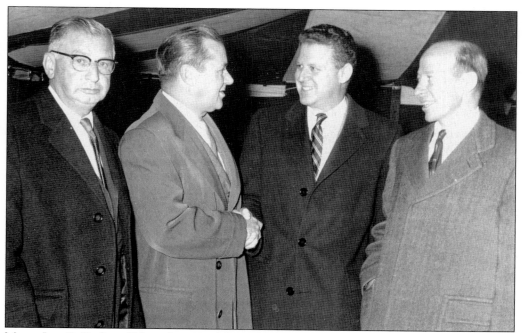

Mayor Leo P. Carlin of Newark, second from the left, congratulates Joel Schwarz, president of the Newark Y at the consecration ceremonies for the projected new Y on Chancellor Avenue and Aldine Street. With them are Samuel I. Kessler (far left) and Richard Scudder. (Courtesy Jewish Historical Society of MetroWest Archives.)

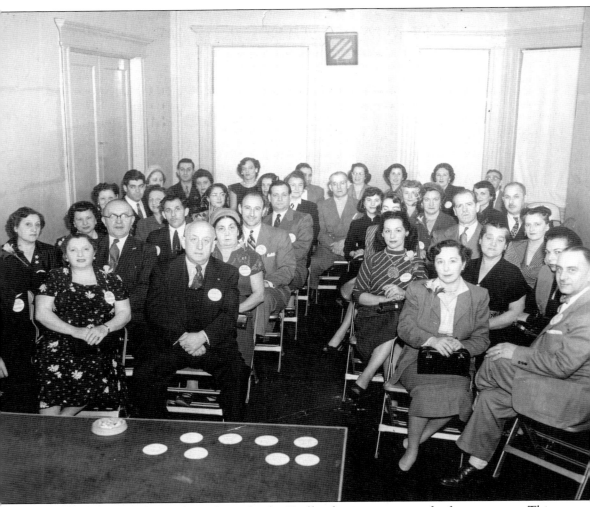

Always in the forefront of social trends, the Y offered a support group for foster parents. This photograph appeared in the *Jewish News* in 1953. The group met at the Weequahic Jewish Center. The occasion was a foster parents' party. (Courtesy Jewish Historical Society of MetroWest Archives.)

HEBREW SHELTERING HOME

214 CHANCELLOR AVE., NEWARK, N. J. 07112

Our Aim ☞ Feeding the Hungry, Sheltering the Homeless

Will you help us in our endeavors? Be a participant in this noble tradition started by our forefather Abraham.

I WISH TO ENROLL AS A MEMBER ☐ $_____

I WISH TO DONATE ANNUALLY ☐ $_____

Name_____

Address_____

The Hebrew Sheltering Home, located on Chancellor Avenue, began operating in 1923 to serve the specific needs of Newark's Orthodox Jews. The home was an agency under the Essex County Jewish Community Council's auspices. The building became a mosque, Newark Community Masjid, in the early 1980s. (Courtesy Jewish Historical Society of MetroWest Archives.)

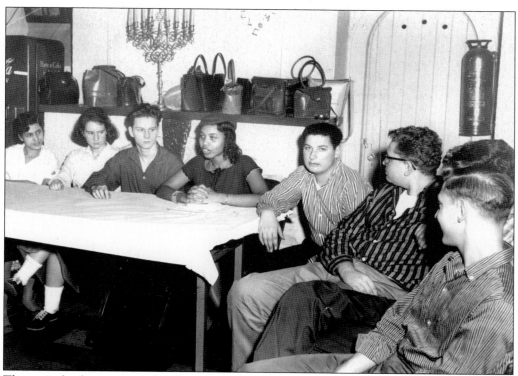

The topic for discussion at this Y teen panel in 1957 is not known. (Courtesy Jewish Historical Society of MetroWest Archives.)

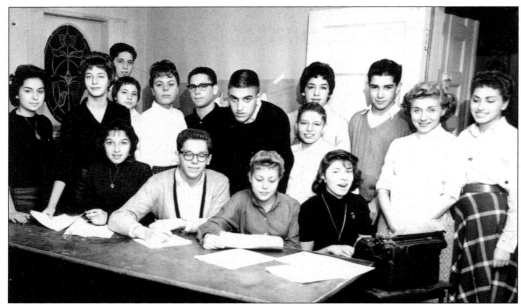

There was a Newspaper Club at the Y in the 1950s. Featured are, from left to right, (first row) Judy Davis, editor Marvin Schram, Brenda Rubin, and Cookie Cohen; (second row) Joyce High, Joel Koenigsberg, Lenny Malk, Tina Kutin, Linda Eisenfeld, Alan Kurtz, Steve Goodman, Linda Green, Mort Lutzke, Chuck Kram, Esther Glyn, and Shari Silverstein. (Courtesy Jewish Historical Society of MetroWest Archives.)

In March 1964, the Jewish community paid tribute to George Kahn for his 40 years of service to the Y. Also honored was Fritz Satz (left), director of physical education. The evening featured a performance of the play Act One, written, produced, and directed by Dore Schary. (Courtesy Jewish Historical Society of MetroWest Archives.)

George Kahn, seated center, is flanked by local residents who were cast members of Kahn's Bits of Hits cabaret musical production. Kahn was a mentor to playwrights Moss Hart and Dore Schary. (Courtesy Jewish Historical Society of MetroWest Archives.)

Born in Newark, Ruth Kaplan Cooper met her first husband, Milton Kaplan, when he spotted her at a Jewish Y dance. Cooper was the first Jewish woman to achieve the title of Mrs. Newark, in 1949. Son Kenneth Kaplan recalls the win: "It was exciting. Newark was a small community, and everybody knew she had the title." (Courtesy Seymour Some.)

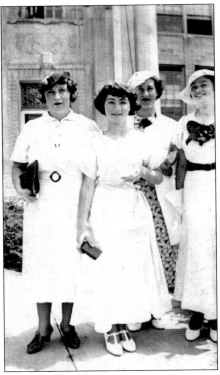

Helen Yeager Gottlieb (second from the left) lived on Leslie Street. As an adult she was a caseworker for the National Council of Jewish Women at the Bureau of Service to the Foreign Born. Weequahic became home to a number of Jews who fled Europe after the Holocaust. (Courtesy Helen Yeager Gottlieb.)

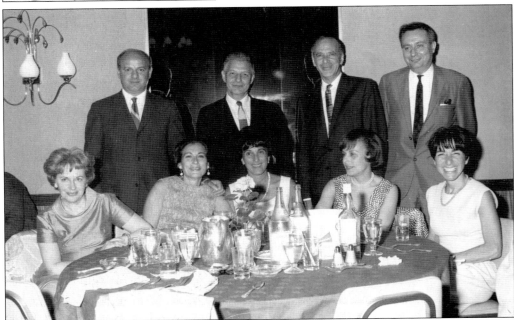

Community leaders attending the May 1967 Chancellor Avenue Y annual meeting include, from left to right, (first row) Ethel Weinstein, Mitzi Reisen, Sima Jelin, Joan Levin, and Ruth Sagner; (second row) Clarence Reisen, Sidney Weinstein, Martin Levin, and Abe Sudran. (Courtesy Jewish Historical Society of MetroWest Archives.)

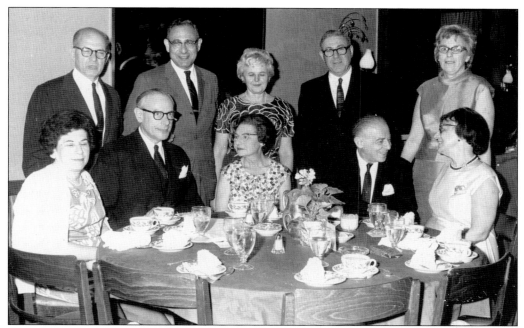

Attending the Chancellor Avenue Y annual meeting in 1967 include William and Mrs. Margulies, Judge and Mrs. Leo Yanoff, Joe and Frances Kruger, Jack and Evelyn Goodstein, and Rabbi Louis and Mrs. Levitsky. (Courtesy Jewish Historical Society of MetroWest Archives.)

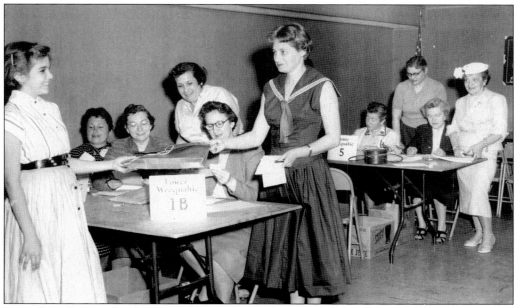

Everything was set for the Lower Weequahic depot's United Jewish Appeal campaign. Gayle Barr (left) turns in a campaign kit to Mrs. Jules Terry. Seated at the first table are, from left to right, Mrs. Louis Zavin, Mrs. Davidi Wallach, and Mrs. Jack Barr with Mrs. Charles Scheller standing. At the rear table are Mrs. Samuel Halperin, Mrs. Julius Friedlander, Mrs. Joseph M. Perrell, and Agnes Gabelson. (Courtesy Jewish Historical Society of MetroWest Archives.)

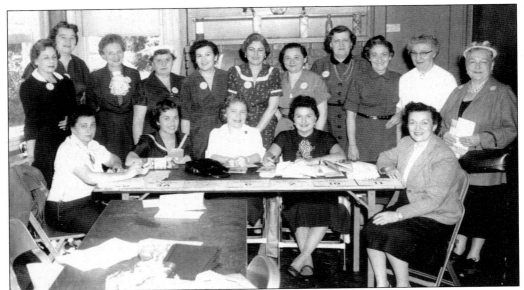

There was a full house at the Upper Weequahic depot. Pictured are, from left to right, (first row) Mrs. Saul Grand, Roslyn Rothbard, Mrs. Emanuel Radoff, Mrs. Franklin B. Guttman, and Mrs. Allen Haberman; (second row) Mrs. Graham Raskein, Mrs. George Moskowitz, Mrs. Ludwig Hutzler, Mrs. Nathan J. Burdeau, Mrs. Jules V. Stark, Mrs. Irving Williams, Mrs. Albert Douglen, Mrs. Leo Arch, Mrs. Harry Lentz, Mrs. Charles Feinberg, and Mrs. Priscilla Pralinger. (Courtesy Jewish Historical Society of MetroWest Archives.)

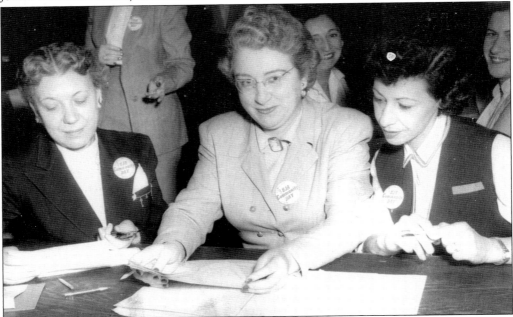

Campaign workers at Community Day in 1953 are checking early reports at the depot at Young Israel Congregation for the Upper and Lower Weequahic area. From left to right are Minna Wildstein, Mrs. Max Dresdner, and Mrs. Joseph Samson, chairs of their respective neighborhoods. (Courtesy Jewish Historical Society of MetroWest Archives.)

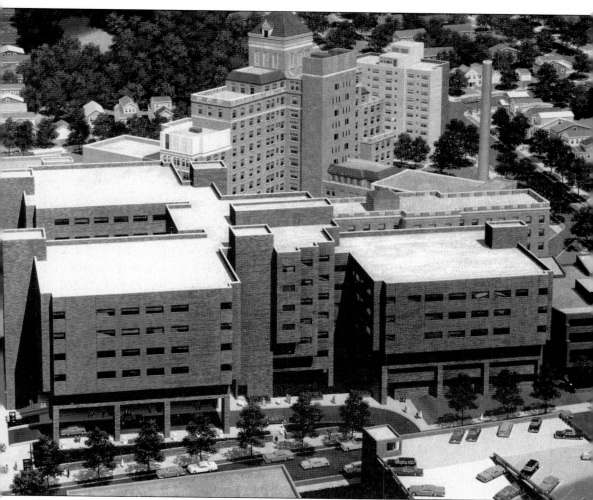

Newark Beth Israel Medical Center sits in the center of the Weequahic neighborhood. The doctors and dentists who worked at the hospital lived and kept offices in Weequahic. The tower and adjacent buildings that are seen in the background of this photograph are the original hospital complex that opened on Lyons Avenue in 1928. The current hospital occupies 1.2 million square feet and is known for its world-class heart transplant program. (Courtesy Newark Beth Israel Medical Center.)

Weequahic's babies were "Born at the Beth," or Newark Beth Israel Hospital. In the background of this photograph is a birth certificate with the footprints of the newborn. New babies were designated as either "Baby Girl" or "Baby Boy" and the family's last name. Thousands of former Weequahic residents have held on to their birth certificates. (Courtesy Jewish Historical Society of MetroWest Archives.)

Dr. Eugene and Rose Parsonnet lived in the Weequahic section from 1925 to 1953. Parsonnet practiced at Newark Beth Israel Hospital, and Rose, among her numerous volunteer activities, was president of the Newark section of the National Council of Jewish Women. Their fathers, Dr. Victor Parsonnet and Dr. Max Danzis, were founders of the hospital in 1901. (Courtesy Jewish Historical Society of MetroWest Archives.)

Dr. Victor Parsonnet represents a third generation of Parsonnet-Danzis doctors on the staff of Newark Beth Israel Medical Center. Parsonnet recalls living on Pomona and Keer Avenues, attending Maple Avenue grammar school, and graduating from Weequahic High School in three and one-half years. Parsonnet is a world-renown cardiac specialist and surgeon and former chairman, as was his father, Eugene, of the New Jersey Symphony Orchestra. (Courtesy Jewish Historical Society of MetroWest Archives.)

Lester Z. Lieberman is a graduate of Weequahic High's class of 1948. A former chairman of Newark Beth Israel Medical Center, Lieberman engineered and negotiated the sale of the hospital to St. Barnabas Health Care System in 1996. This was the first acute-care hospital ever to be sold in New Jersey. Lester serves as chairman of the Healthcare Foundation of New Jersey and is accepting an award on behalf of the foundation from Best Friends, a nationwide network that offers activities for adolescents to Weequahic's elementary schools. (Courtesy Lester Z. Lieberman.)

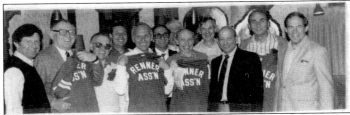

The Sunday Morning Photo, from left, Ed Pack, Bill Pack, Ken Kaufman, Dave Horwitz Hank Hirsch, Al Berger, Gene X-9 Allen, Mike London. Nate Dumbroff, Bernie Robbins, Len Swimmer, and Gibby Raff. Photographs by Ed Mark.

The Renner Association, a group of youngsters who hung out on the corner of Renner and Goodwin Avenues, rented a room, purchased a television, have kept in touch for more than 60 years. Its early members include Ed Mark, Larry Stern, Nate Dumbroff, Fred Levy, Ted Dumbroff, Bernie Wallman, Bob Hilton, Shep Sternin, George Greenberg, and Seymour Abrahamson. Other members include Leon Steinhauer, David Horwitz, Marv Jacobs, Dave Cohen, Hank Hirsch, Howie Sofman, Al Berger, and Gibby Raff. (Courtesy David Horwitz.)

Arthur Tauber

Arthur Tauber, 74, of 360 Badger Ave., Newark, a tool and die maker, died Dec. 27. Born in Austria, he came to Newark when he was 18. He was owner of the Tauber Manufacturing Co., Newark.

He is survived by his wife, Mrs. Sadie G. Tauber; four sons, Louis and Leonard of Newark, George of Fair Lawn and Stanley of Hastings, N.Y.; a daughter, Mrs. Jeanette McDonald of Irvington, N.Y; and seven grandchildren. Services were conducted Dec. 29 at Barrish Funeral Home by Rabbi Alter Kriegel. Burial was in Beth Israel Cemetery, Woodbridge.

—○—

SYNAGOGUE DIRECTORY

ADAS ISRAEL AND MISHNAYES, 246 Shepherd Ave., Newark. Rabbi Israel E. Turner.
AGUDATH ISRAEL, 112 Custer Ave., Newark. Rabbi Jacob Zakheim.
AGUDATH ISRAEL, Academy Rd., near Elizabeth St., Caldwell. Dr. Morris R. Werb. Cantor Israel Goldstein.
AHAVAS ACHIM B'NAI JACOB, 391 Avon Ave., Newark. Rabbi Hershel Cohen.
AHAVAS SHOLOM, 145 Broadway, Newark. Dr. Marion Guttman.
AHAVATH ACHIM, 121-139 Academy St., Belleville. Rabbi Victor Cohen.
AHAVATH ACHIM BIKUR CHOLIM, Chancellor Ave. and Philip Pl., Irvington. Rabbi Leon J. Yagod. Cantor Jacob Korbman.
AHAVATH ISRAEL, WAINWRIGHT STREET, 269-271 Wainwright St., Newark. Rabbi Mordecai Ehrenkrantz.
AHAVATH ZION, 153 16th Ave., Newark.

Rabbi Sholom B. Gordon.
ANSHE LUBOWITZ, 247 W. Runyon St., Newark. Rabbi Samuel Liebman.
ANSHE ROUMANIA KEDUSHAS LEVI RABBEINU KONVITZ, 198 Chadwick Ave., Newark. Rabbi Jacob Tellem.
BETH AHM, Baltusrol Way, Springfield. Rabbi Reuben R. Levine. Cantor Irving Kramerman.
BETH DAVID JEWISH CENTER, 828 Sanford Ave., Newark. Rabbi Julius Eldenbaum. Cantor Morris Ovici.
BETH EL, 222 Irvington Ave., 50 Orange. Dr. Theodore Friedman. Cantor Morris Levinson.
BETH EPHRAIM-MAPLEWOOD JEWISH CENTER, 520 Prospect St., Maplewood. Rabbi I. H. Burnstein. Samuel Gelber, lay cantor.
BETH HAKNESSET MERKAZ HATORAH, 100 Chancellor Ave., Newark.
BETH ISRAEL OF THE ORANGES, 42 High St., Orange, and 500 Pleasant Valley Way. West Orange. Rabbi Yaakov D. Rennert.
BETH SHALOM, 193 E. Mt. Pleasant Ave., Livingston. Rabbi Samuel Cohen. Cantor Henry Butensky.
BETH SHALOM, Vaux Hall Rd. at Plane St., Union. Dr. Elvin I. Rose.
BETH TORAH, Reynolds Terrace, Orange. Rabbi Arnold A. Lasker. Cantor Henry Fried.
B'NAI ABRAHAM, Clinton and Shanley Aves., Newark. Dr. Joachim Prinz. Cantor Nathaniel Sprinzen.
B'NAI ISRAEL, 780 Kearny Ave., Kearny. Rabbi Sidney M. Bogner.
B'NAI ISRAEL, 221 Cleveland Ave., Harrison.
B'NAI ISRAEL, 708 Nye Ave., Irvington. Rabbi Benjamin H. Englander. Cantor Moshe Weinberg.
B'NAI ISRAEL, 162 Millburn Ave., Millburn. Dr. Max Gruenewald. Cantor Joshua O. Stiel
B'NAI ISRAEL, 605 Belmont Ave., Newark. Rabbi Herman Friedman.
B'NAI ISRAEL, 192 Centre St., Nutley. Rabbi Hyman Danzig. Cantor Morris Avshrom.
B'NAI JESHURUN, High St. and Waverly Ave., Newark. Rabbis Ely E. Pilchik. Barry H. Greene, Cantor Norman Summers.
B'NAI MOSHE, 19-29 Ross St., Newark.
B'NAI ZION, 430 Franklin St., Bloomfield. Rabbi Sheldon Thall, Cantor Samuel J. Morginstin.
CHEVRAH THILIM TIFERETH ISRAEL, 680 Chancellor Ave., Irvington. Rabbis David Freedman, Benjamin Finkelstein.
CONSERVATIVE CONGREGATION OF HILLSIDE, 919 Salem Ave., Hillside. Rabbi H. Beryl Lasker, Cantor Bernard Saitz.
DAUGHTERS OF ISRAEL PLEASANT VALLEY HOME, 651 High St., Newark. Rabbi Ezyrel Silberfeld.
EMUNATH ISRAEL, 175 Brookwood St.,

East Orange. Rabbi Israel Goldblum.
JEWISH CENTER OF WEST ORANGE, 300 Pleasant Valley Way, West Orange. Rabbi Harold Mozeson. Cantor Murray Bazian.
JEWISH COMMUNITY CENTER OF VERONA, 56 Grove Ave., Verona. Rabbi Alter Kriegel.
KEHILATH ISRAEL, 152 Osborne Ter., Newark. Rabbi Louis Weller.
KESER TORAH, Bragaw Ave., and Clinton Pl., Newark. Rabbi Saul Zin.
KNESSET ISRAEL, 882 Bergen St., Newark. Rabbi Philip S. Greenstein.
LEV ISRAEL, 274 Chancellor Ave., Newark. Rabbi A. L. Spitz.
MACHZIKAI HADATH, Hobson St. and Nye Ave., Newark. Rabbi Leib Bornstein.
MOUNT SINAI CONGREGATION, 250 Mt. Vernon Pl., Newark. Rabbi Abraham Pelberg.
OHEB SHALOM, 170-180 Scotland Rd., South Orange. Dr. Louis M. Levitsky. Cantor Edgar Mills.
RODFEI SHOLOM, 237 Clinton Pl., Newark. Rabbi S. Murray Halpern.
ROSEVILLE B'NAI ZION, 545 West Market St., Newark. Rabbi Oscar Kline.
SHAREY SHALOM, Temple House, 78 S. Springfield Ave., Springfield. Rabbi Israel Dresner.
SHAREY TEFILO, 57 Prospect St., East Orange. Rabbi Avraham Soltes. Cantor Herman Dansker.
SHOMREI EMUNAH, 67 Park St., Montclair. Dr. Jeshaia Schnitzer, Cantor Elliot Levine.
SINAI CONGREGATION, 1531 Maple Ave., Hillside. Rabbi Eliezer Cohen.
TALMUD TORAH, 182 Osborne Ter., Newark.
TEMPLE BETH EL, 1721 Clinton Pl., Elizabeth. Rabbi Milton G. Miller.
TEMPLE EMANU-EL OF WEST ESSEX, 264 W. Northfield Rd., Livingston. Rabbi Herbert H. Rose, Cantor Sheldon Rose.
TEMPLE ISRAEL OF ORANGES AND MAPLEWOOD, 432 Scotland Rd., South Orange. Rabbi Herbert Weiner. Cantor Adolphe Argand.
TEMPLE ISRAEL OF UNION, 2372 Morris Ave., Union. Rabbi David Friedberg. Cantor Sidney Morris.
TEMPLE MENORAH, 934-952 Broad St., Bloomfield. Rabbi Nathan Fish.
TEMPLE SHOLOM OF CEDAR GROVE, 760 Pompton Ave., Cedar Grove. Rabbi Harold Spivack.
TIFERETH ZION, 176 Clinton Pl., Newark. Rabbi David Singer.
TORAS EMES, 76 Jefferson St., Newark.
TORAH-HASIDIC CENTER, 213 Chancellor Ave., Newark. Rabbi Abraham Liefer.
TORATH CHAIM JEWISH CENTER, 219-229 Schley St., Newark. Rabbi Herman L. Kahan.
YOUNG ISRAEL, Maple and Weequahic Aves., Newark. Rabbi Zev Segal. Cantor Eugene Schreiber.

At one time, Weequahic was home to 17 small shuls, or synagogues. Their existence is documented in the 1962 synagogue directory published by the *Jewish News*. (Courtesy Jewish Historical Society of MetroWest Archives.)

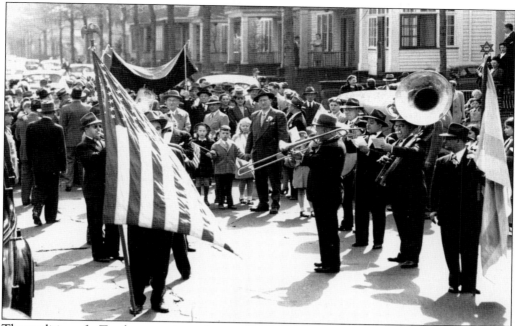

The tradition of a Torah procession, where a synagogue's congregants carry their sacred scroll to a new building, was a festive occasion. (Courtesy Ruth Krichman Brief.)

WAINWRIGHT STREET SYNAGOGUE
209-211 Wainwright Street • Newark, New Jersey

A Happy New Year 1948-1949 לשנה טובה תכתבו

איינלאם קארטע פאר

סליחות, ראש השנה, יום כפור

October 13th October 4th and 5th September 25th

Our worthy Rabbi and Cantor MAX EHRENKRANTZ will officiate

וויינרייט סטריט שוהל

209 וויינרייט סטריט, נוארק, נ. דזש.

אונזער בארימטער רב און חזן מרדכי עהרענקראנץ

וועט פארבעטען

$7.00 49 מענער טיקעט

14 CENTER C

No.

A High Holiday ticket from 1948 for the Wainwright Street synagogue turned up unexpectedly in a prayer book and was donated to the Jewish Historical Society of MetroWest by Sheba Mittelman and Lee Saal. (Courtesy Jewish Historical Society of MetroWest Archives.)

Ahavath Israel, or Wainwright Street synagogue, is still standing. Today it is Union Chapel Church and has an active African American Episcopal congregation. (Courtesy Jewish Historical Society of MetroWest Archives.)

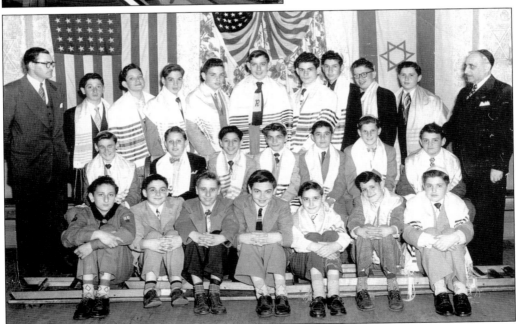

The location of this photograph is Torath Chaim Jewish Center, also known as the Schley Street synagogue. The synagogue opened in 1932. The rabbi was Herman L. Kahan. This class of young boys would have taken their Hebrew school lessons from Gedaliah Convissor, on the right. (Courtesy Sam Convissor.)

The Hebrew letters on the top of this report card say "Talmud Torah." It appears that Sam Convissor's grades were good enough to get him advanced to the third grade. (Courtesy Sam Convissor.)

REPORT CARD

תלמוד תורה

UNITED HEBREW SCHOOLS
of Newark, N. J.

Louis Halberstadter, Superintendent

Name *Convissor, Sam*

Class *2nd class* (2A)

Teacher *Mr. Horowitz*

	1st	2nd	3rd	4th	5th	6th	
Reading	98	100	100	100	100	100	קריאה
Hebrew	90	95	80	80	85	85	לשון
Bible	95	95	80	80	88	90	חומש
History	93	95	95	95	95	95	הסטוריה
Mishna	—		—				משנה
Gemara	—	—	—				גמרא
Jewish	95	98	95	95	95	95	יהודית
Writing	90	90	90	90	90	90	כתיבה
Religion	95	100	100	100	98	100	דת
Effort	90	95	95	95	85	88	שקידה
Conduct	95	98	95	78	80	85	הנהגה
Absent	—	—	1	1	4	2	חיסור
Late	—	—	—	—	—	—	איחור

100—Excellent 80—Good
90—Very Good 70—Passing Mark

RELIGIOUS SCHOOL
YOUNG ISRAEL OF NEWARK
Pupil *Blumenfield, Judith* Grade I B3

III	II	I			
		C +	Reading	קריאה	
		C +	Writing	כתיבה	
		B	History	הסתוריה	
			Language	עברית	
			Religion	דת	
			Yiddish	אידיש	
			Bible	חומש	
		A	Effort	שקידה	
		A	Conduct	הנהגה	
		A	Neatness	סדר	
		8	Absent	חסר	
		—	Late	אחר	

Parent's Signature
Please Sign this Card and return it to School

First Cycle ...
Second Cycle ...
Promoted to grade*Ruth Schulman*..............
Teacher..
Date *11/8/43* ...

Young Israel synagogue was run by Rabbi Zev Segal. Along with its religious school, former resident Felice Blank recalls the group the rabbi ran on Saturday afternoons that attracted youngsters who met at the synagogue for singing and dancing and celebrating the Sabbath in the 1940s and 1950s. (Courtesy Judy Blumenfeld Schatzberg.)

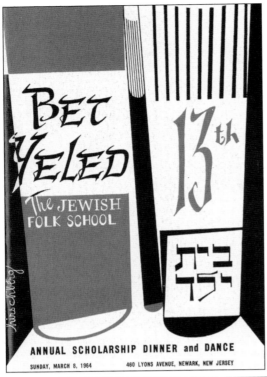

BET YELED
The JEWISH FOLK SCHOOL

13th

ANNUAL SCHOLARSHIP DINNER and DANCE
SUNDAY, MARCH 8, 1964 460 LYONS AVENUE, NEWARK, NEW JERSEY

In addition to the Orthodox Talmud Torahs, there was Bet Yeled, a Jewish folk school founded in 1950 by parents associated with the Labor Zionist movement. The school was housed in the Newark Jewish Cultural Center on Clinton Place near Hawthorne Avenue before it relocated to Lyons Avenue. (Courtesy Jewish Historical Society of MetroWest Archives.)

The Avon Avenue shul, with Hescheleh Cohen as its rabbi, merged with Ahavas Achim B'nai Jacob and David now located in West Orange. The building still has reminders of its Jewish origins. Above the center top window and etched into the stone is a Magen David, or Jewish star, and above the star are the outlines of a tablet with the Ten Commandments. (Courtesy Ruth Dolinko.)

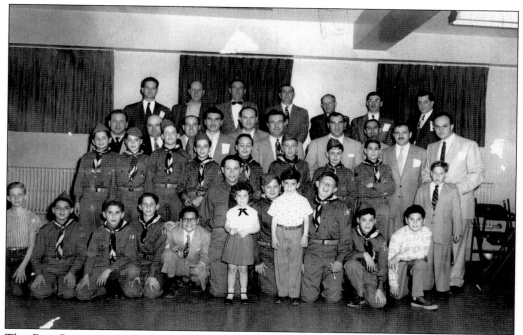

The Boy Scouts are attending what appears to be a father-and-son get-together. It is Troop 19. The scouts met at the Y and area synagogues. (Courtesy Jewish Historical Society of MetroWest Archives.)

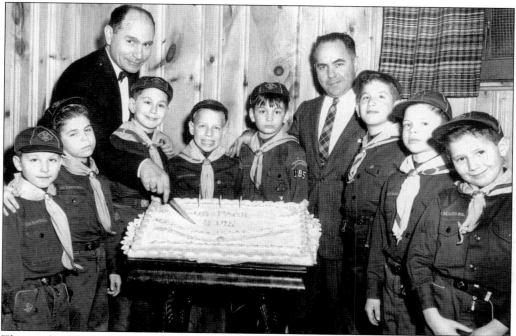

This pack of Cub Scouts, Troop 195, is from Hillside. The boys and their leaders met at the Chancellor Avenue Y. The photograph was taken in February 1959. (Courtesy Jewish Historical Society of MetroWest Archives.)

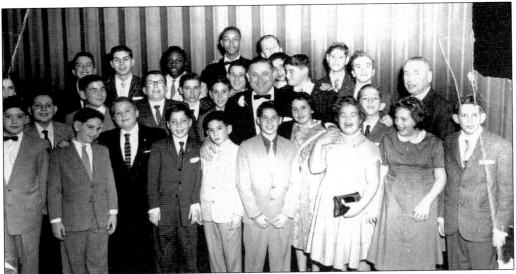

Jerry Wichinsky, class of 1964, recalls the popular South Ward Boys Club started by Dave Warner. The group met upstairs at the Hawthorne Avenue movie theater and held an annual dinner dance at the Essex House Hotel in downtown Newark. This c. 1959 photograph features Dave Warner surrounded by Ira Libman, Alan Dunst, Norman and Helen Levine, Larry Wertzel and his sister, Barbara, Johnny Teeple, Alan Pollak, Stuie Schultz, Lenny Weinick, Jeff Davis, Saul Kelton, and others. Jerry Wichinsky and brother Alan are not in the picture. (Courtesy Jerry Wichinsky.)

An argument can be made that Rutgers University in Newark was a Jewish institution as it was the school of choice of numerous Weequahic graduates. Here are (from left to right) longtime friends, Marvin Semel, Gary Skoloff, and Sheldon Belfer attending a Reserve Officers' Training Corps ball in 1953. (Courtesy Sheldon Belfer.)

Weequahic's youngsters belonged to assorted social clubs and sports-related groups. Taken at a class reunion in 1998, this photograph features members of the Redskins. Those holding the jacket are (from left to right) Marty Shumsky, Harvey "Hitzy" Belfer, David "Kudo" Rauch, and Richie Roberts. The men are members of Weequahic High School's class of January 1956. (Courtesy Donald M. Kaufman.)

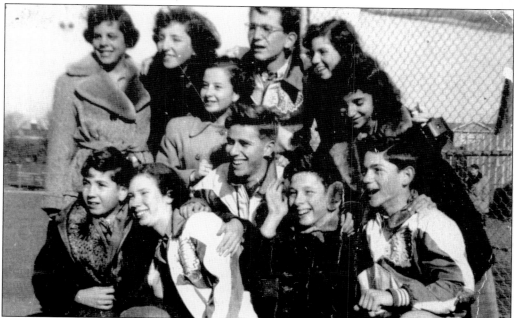

The faces of 1950s youngsters include Norma Fisher, Lance Posner, Shirley Ezersky, Phyllis "Flip" Shafer, Barbara Gralla, Richie Roberts, Jimmy Williams, Matty Blumenfeld, Howie "Schnitzy" Schneider, Roger Kulka, Joan Weisman, Betty Shereshewsky, Anita Klass, and Nedra Siegel. (Courtesy Donald M. Kaufman.)

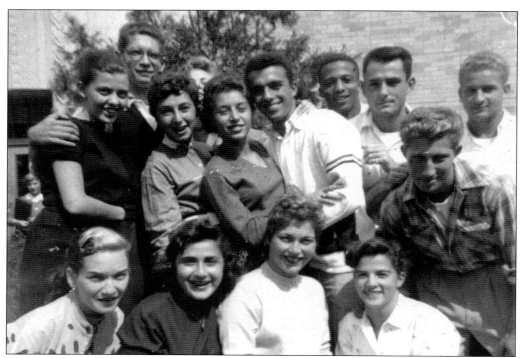

In this photograph taken at the Chancellor Avenue School playground, a regular hangout for neighborhood youngsters, are Janice Pelzman, Vicki Wodnick, Linda Sarnow, Judd Kessler, Bernice Sokolov, Murray Shereshewsky, Don Kaufman, Errol Meisner, and others. (Courtesy Donald M. Kaufman.)

Bob Goldberg, class of 1955, recalls that Passover seder at the Goldberg household on Hobson Street was a special event. Furniture was moved from his parents' bedroom, and the table was set up for the family dinner. One can see the bedroom dresser in the background of the photograph. (Courtesy Bob Goldberg.)

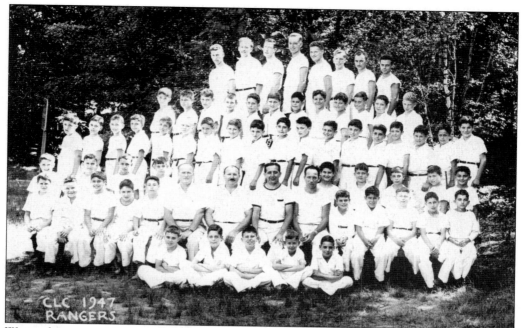

Weequahic youngsters attended the Y camp, Cedar Lake Camp, which was located in Milford, Pennsylvania. (Courtesy Bob Goldberg.)

A sports club, the Indians, held a party in Erwin Solomon's basement in 1950. According to Ed Freedman, Weequahic had six or seven social and athletic clubs. Pictured are, from left to right, (first row) Butch Chernin, Rudi Feuerstein, Larry Sussnow, Ed Freedman, and Burt Morachnick; (second row) Eddie Burns, Mark Feiner, Erwin Solomon, Arnie Taub, Steve Radin, Les Novick, Irve Moskowitz, Sid Koretsky, Mike Feldman, unidentified, Marv Feinblatt, Mort Stenzler, and Buddy Mayerson. (Courtesy Ed Freedman.)

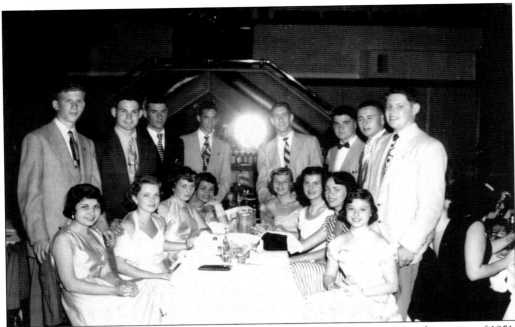

There were a number of fraternities and sororities. This is a fraternity party in the spring of 1951. (Courtesy Gayle B. Jacobs.)

PAVILION AND BOARDWALK, BRADLEY BEACH, N. J.

This postcard is a reminder that the Jersey Shore and Bradley Beach were extensions of Weequahic during the summer months. (Courtesy Donald M. Kaufman.)

Forever young, Betsy Rosenberg Krichman lived at 9 Keer Avenue. Krichman provides the perfect ending for Weequahic's Jewish history. As a student at Trenton State College, her term paper, "A Survey of the Weequahic Section of Newark, New Jersey, as of January 1961," concludes that, "The Weequahic section is one of the finest residential communities in the City of Newark. [However] 'the most pressing and unsolved problem of the community is the changing neighborhood and racial shift' going from white and Jewish to 'non-white and foreign born residents.'" Now others would be responsible for Weequahic's legacy. (Courtesy Krichman family.)

ACROSS AMERICA, PEOPLE ARE DISCOVERING SOMETHING WONDERFUL. *THEIR HERITAGE.*

Arcadia Publishing is the leading local history publisher in the United States. With more than 3,000 titles in print and hundreds of new titles released every year, Arcadia has extensive specialized experience chronicling the history of communities and celebrating America's hidden stories, bringing to life the people, places, and events from the past. To discover the history of other communities across the nation, please visit:

www.arcadiapublishing.com

Customized search tools allow you to find regional history books about the town where you grew up, the cities where your friends and family live, the town where your parents met, or even that retirement spot you've been dreaming about.

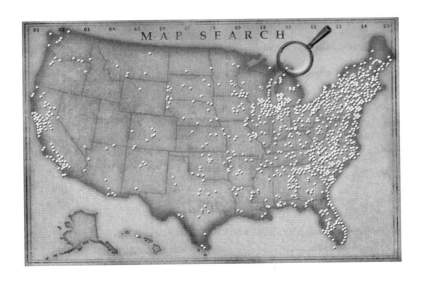